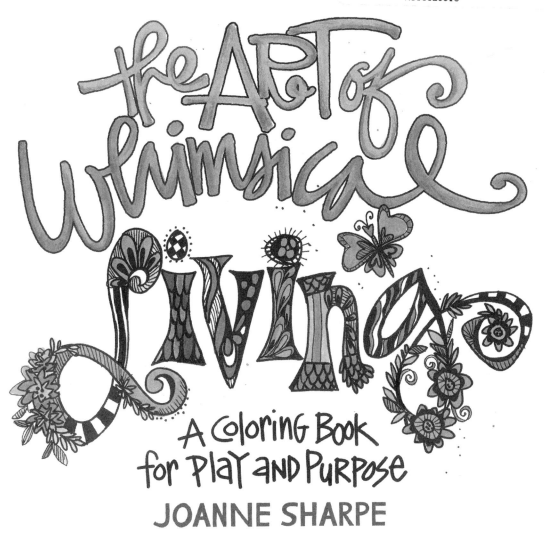

the ART of Whimsical Living

A Coloring Book for Play and Purpose

JOANNE SHARPE

NORTH LIGHT BOOKS
CINCINNATI, OHIO
clothpaperscissors.com

Contents

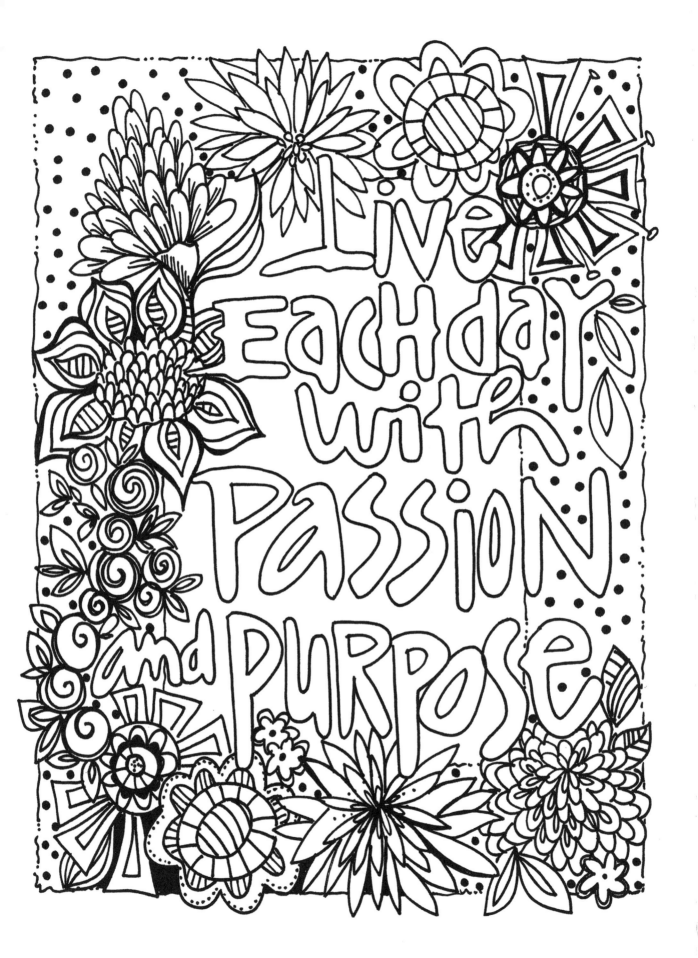

the COLOR-loving LIFE

There is no shortage of coloring book choices on the market today. Who doesn't love to color? For my entire life, coloring has been a favorite pastime as well as a constant element in much of my artwork. Whether I am using marker, paintbrush or colored pencil, coloring gives life to my drawings and design. In this, my debut coloring book, I offer a collection of art that provides you the opportunity for coloring with purpose—an interactive collection of art to be personalized, customized and shared.

Here you will find energetic, whimsical art to color to make every day a colorful masterpiece. Make all the details of your every day a bit more colorful using the imagery on these pages to illustrate each task or message. Make your own gifts, organize your thoughts and activities, document your days or plan your tasks on these pages using your own personal color stories.

Each page is perforated so you can tear out the original and use the art for multiple purposes, saving it to be used over and over again. Use your home printer or a retail copy shop to reproduce the art pages to suit all your creative coloring ideas.

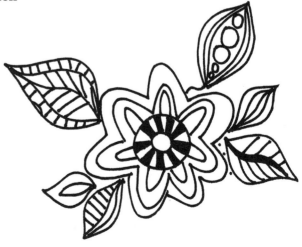

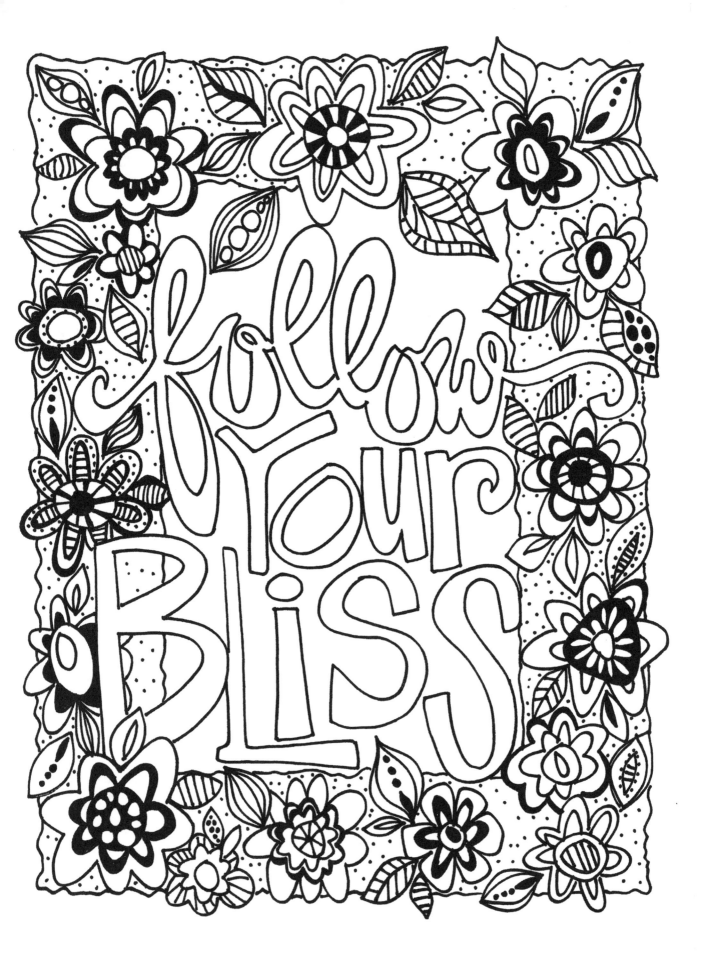

MANTRAS

A mantra is defined as a repeated expression
or idea, most commonly used in meditation.
To me, it's usually a simple phrase that nurtures
a desired mindset, response or feeling.
Make your mantras while coloring art.

- Use the mantra pages to make a collection of colorful life reminders or to share with others.

- Change the size of the original page art and print out assorted sizes, large and small, and color with different color stories, such as cool blues, warm reds, oranges, yellows or hot colors like pink, lime-green and turquoise. Different color schemes can evoke specific feelings and emotional responses.

- After your pieces are sized and colored, store the mantras in a special box or container and use them for personal affirmations or gift giving.

- Display a favorite mantra taped to a mirror or your car dashboard.

- Color and frame a specific mantra as a personal visual inspiration or give one as a gift.

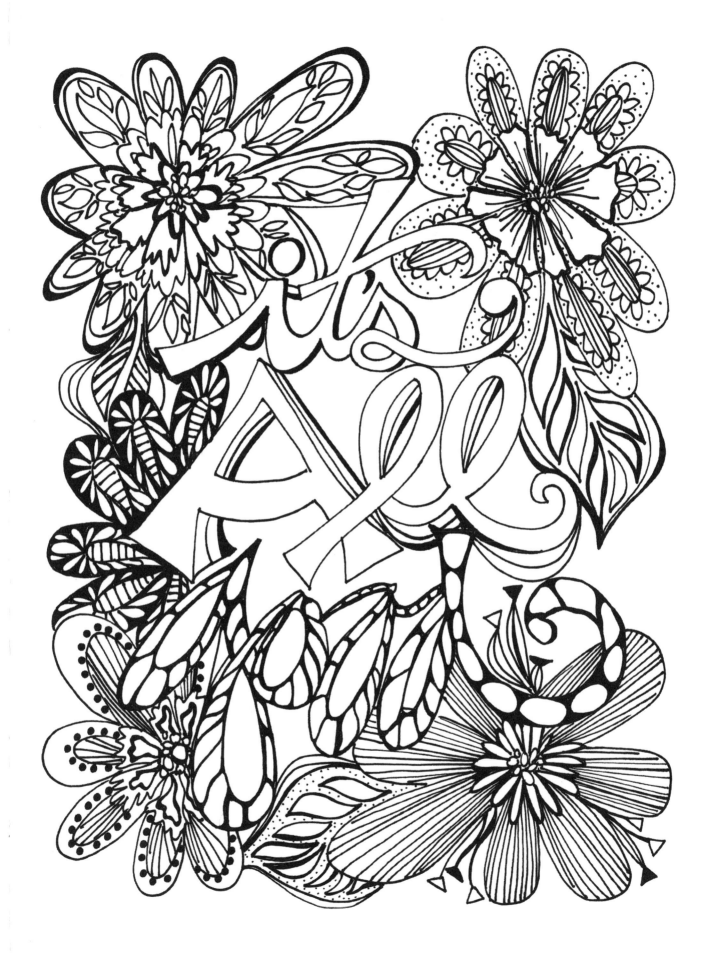

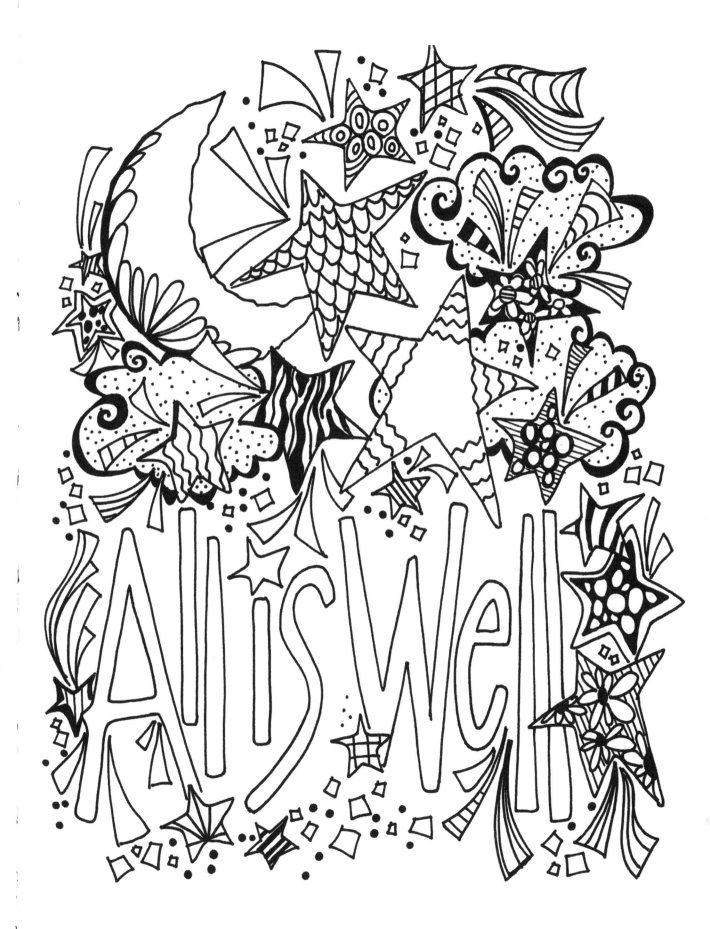

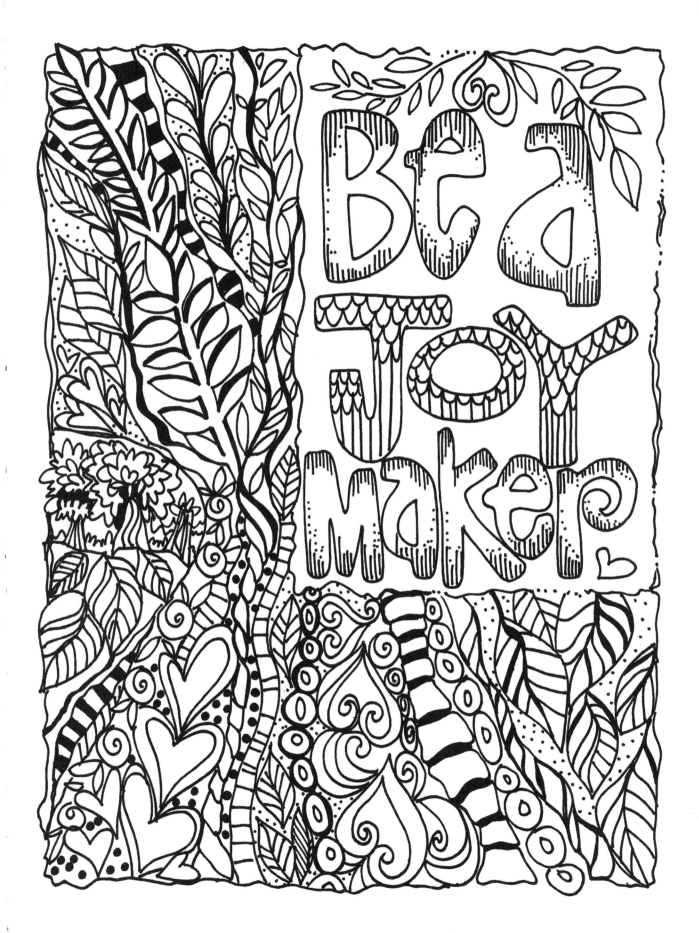

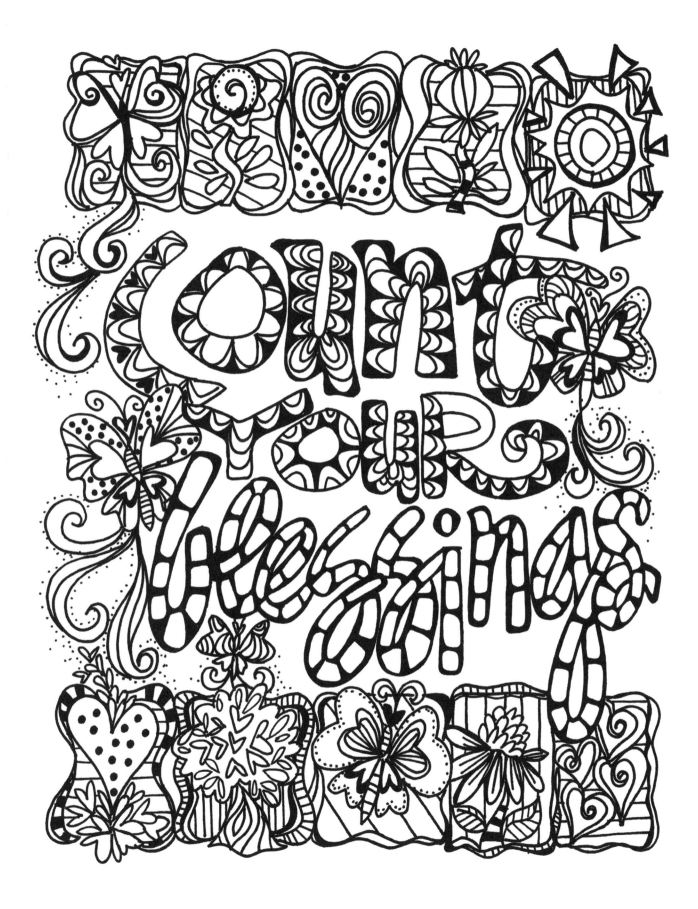

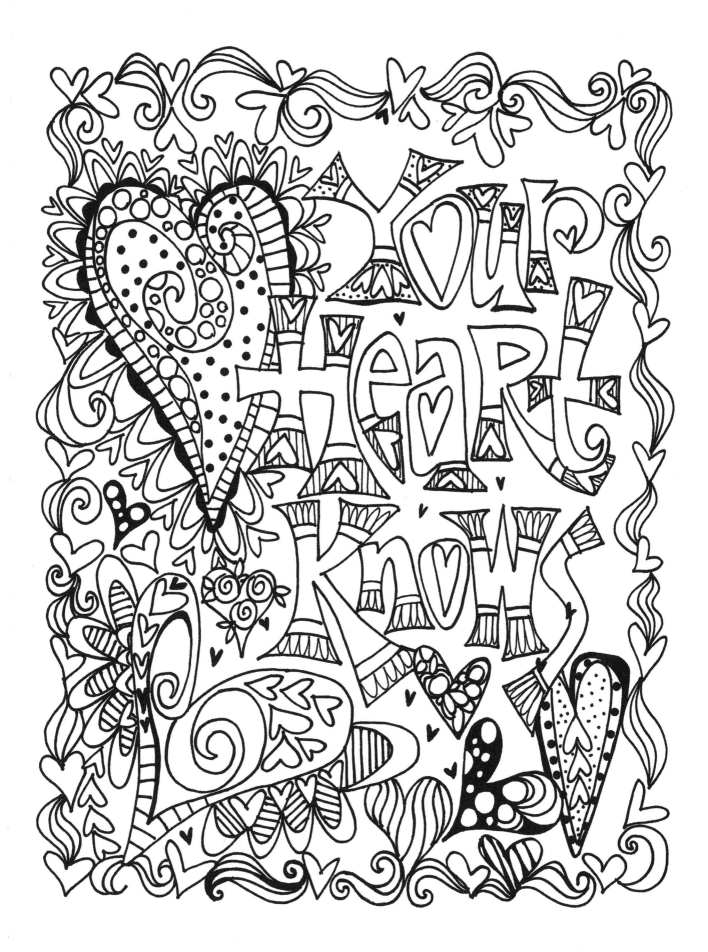

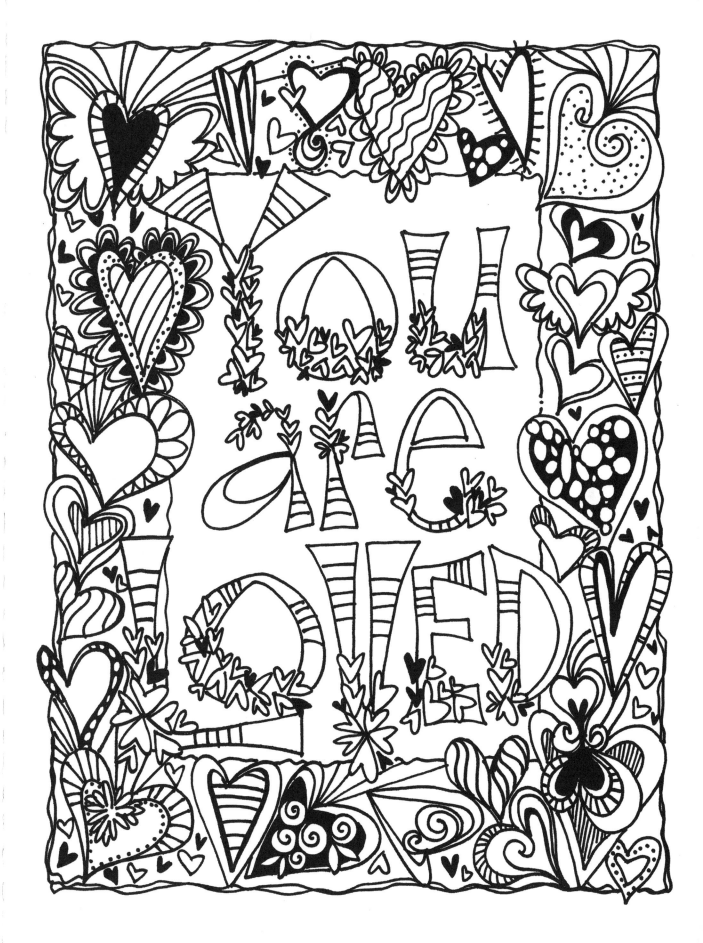

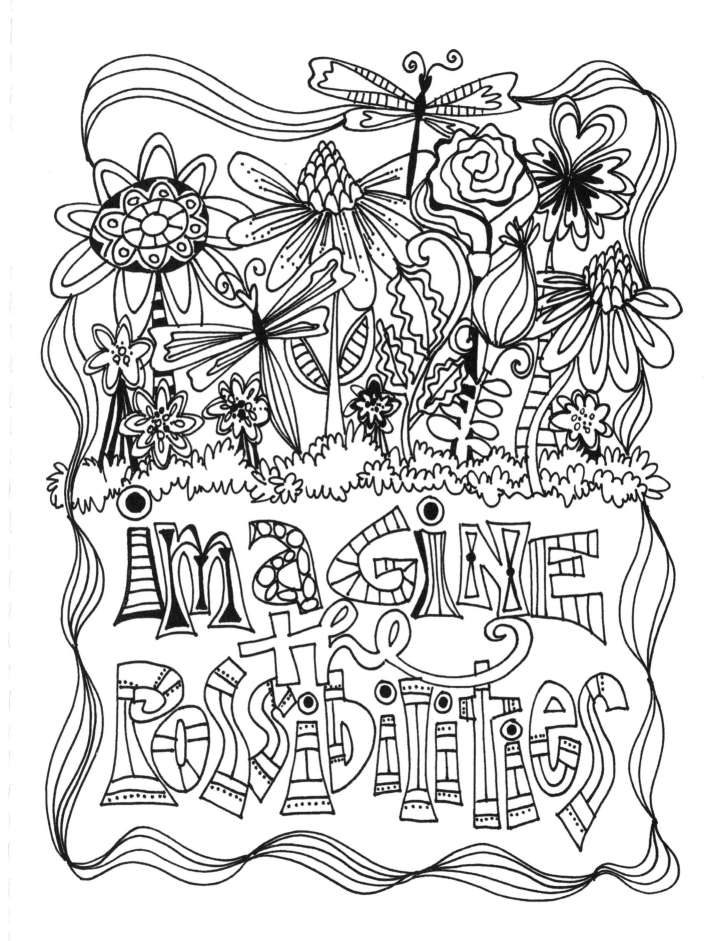

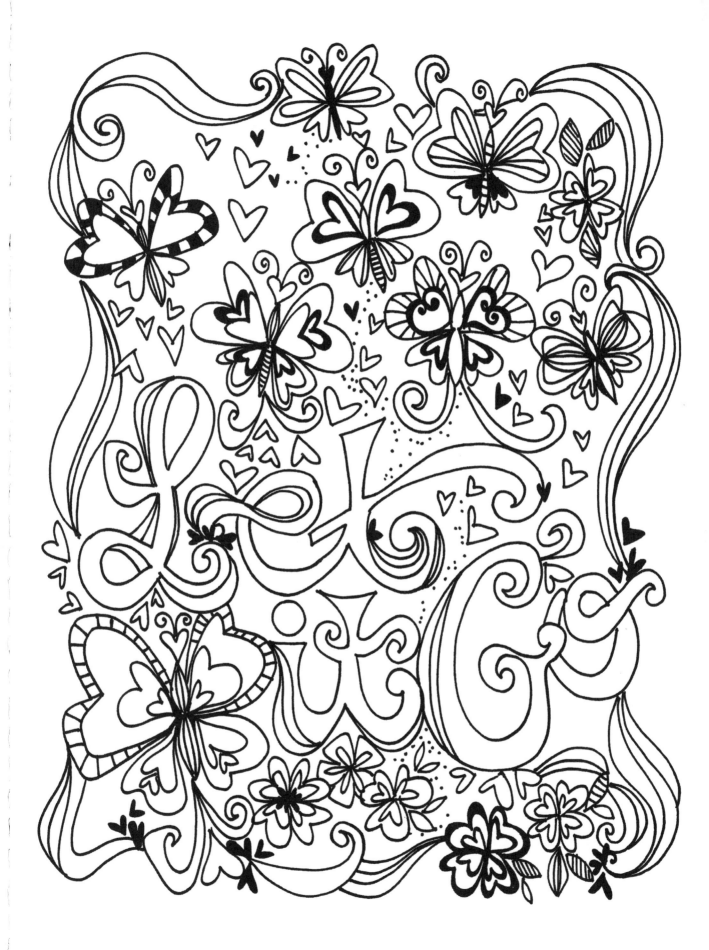

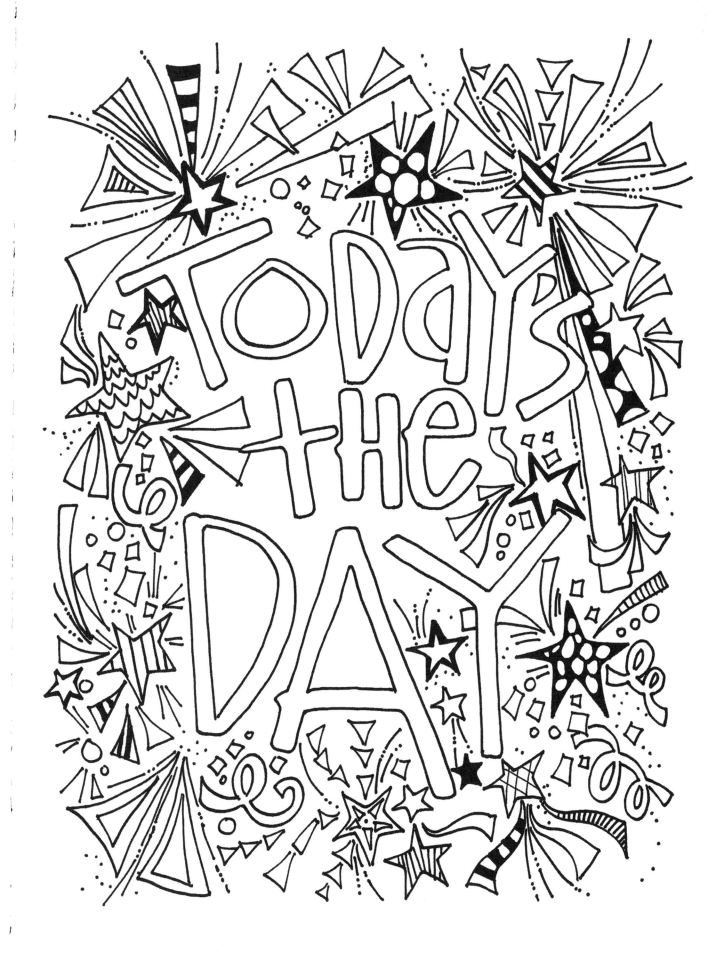

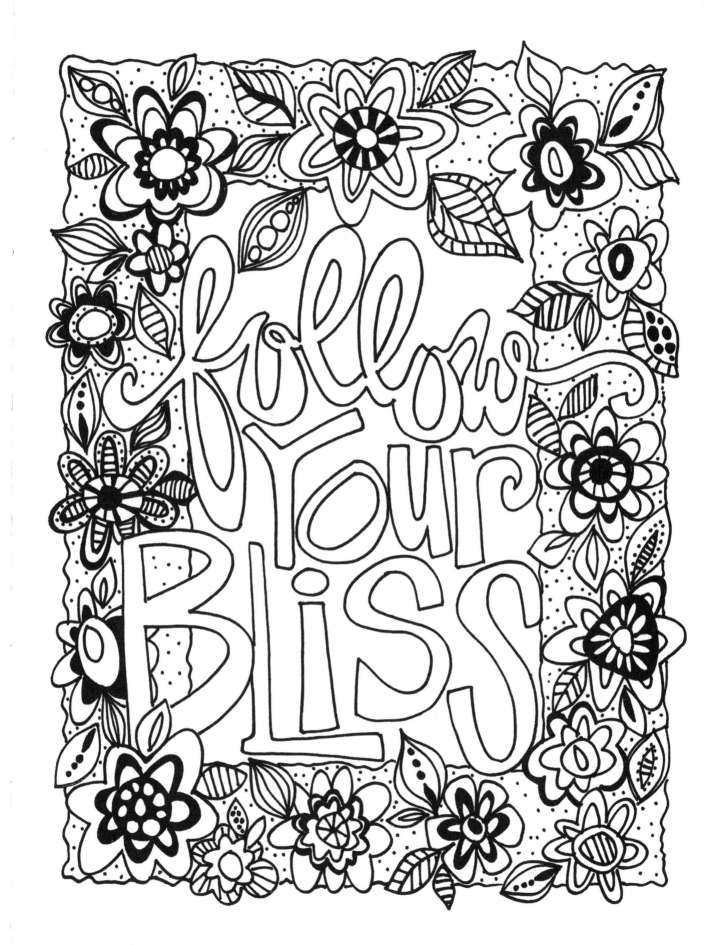

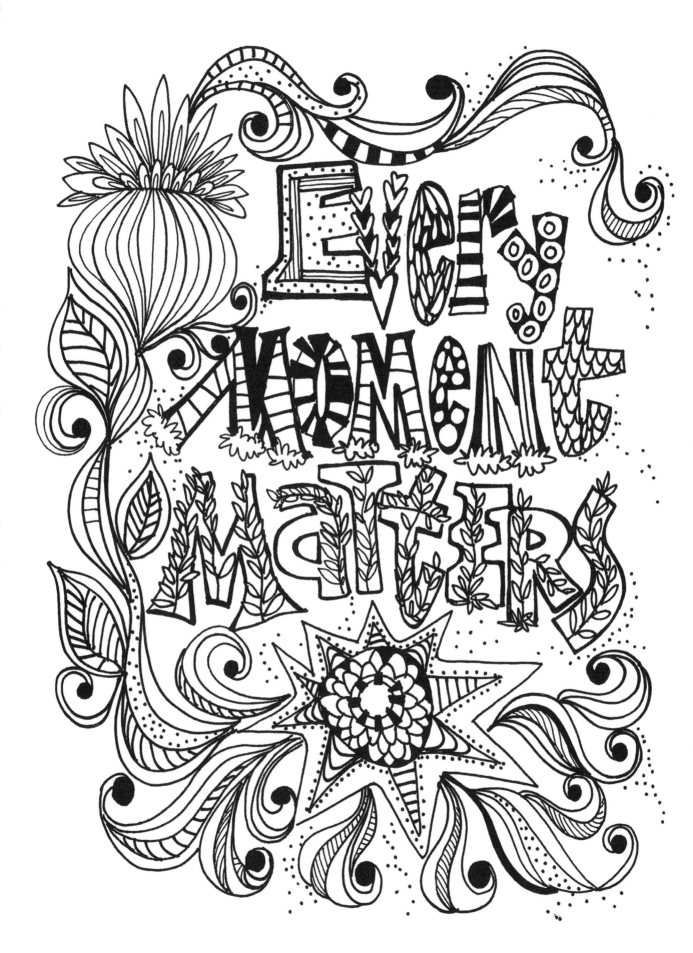

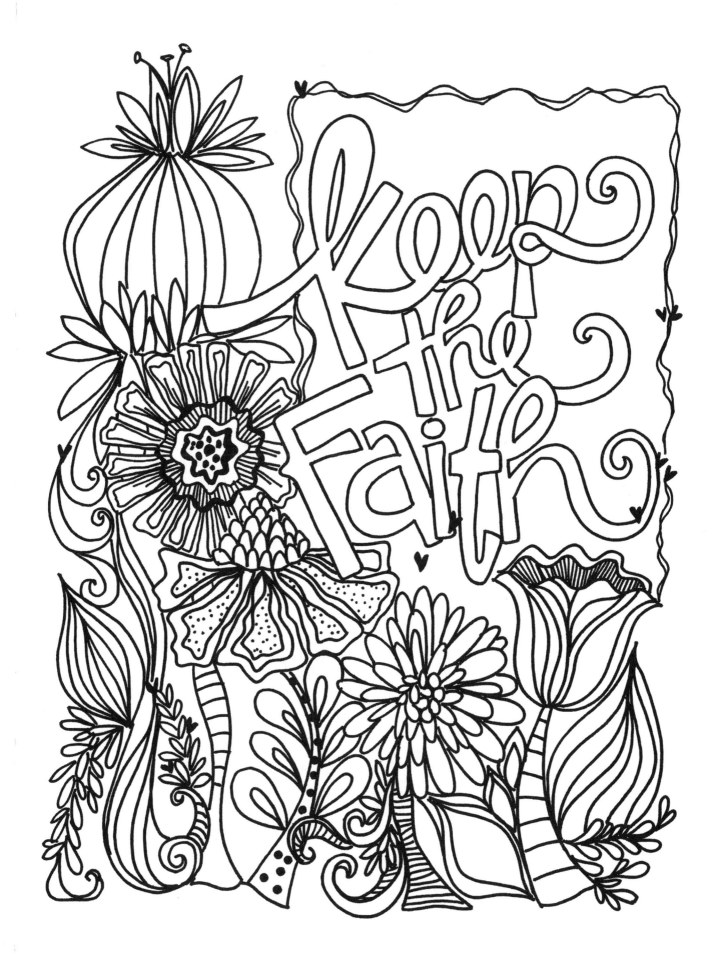

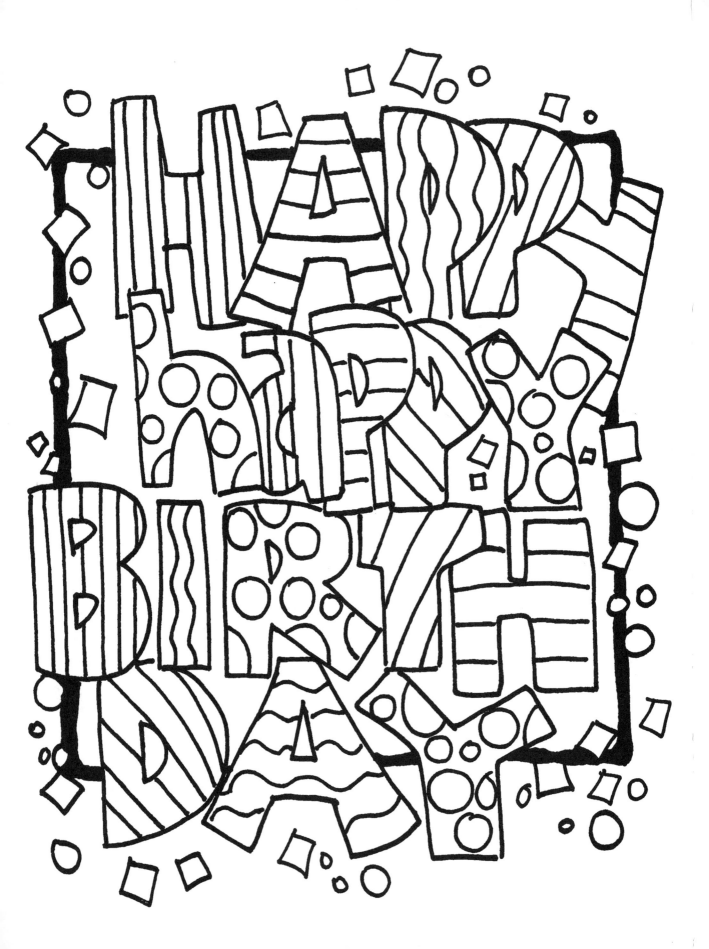

NOTES and MESSAGE CARDS

In this technical, electronic culture we live in, there is something very special about a handmade, heartfelt card or gift. Put your coloring to practical use by creating your own line of colorful greeting cards. Be creative with your techniques, using the art in different sizes and boldly coloring with assorted art supplies like ink pens, watercolor paints and sparkly, glittering gel pens.

- Scan the art from the book page and print onto cardstock before coloring (and sharing!).

- Enlarge or reduce the page art and print onto watercolor paper. Trim the art to create a one-sided panel card and color with water-soluble colored pencils or watercolor paints. Paste the art onto decorative cardstock to create an original masterpiece for gifting.

- Make assorted sizes of the message cards to color and cut. Fussy-cut around the outline edges to make an interesting dimensional shape.

- Keep a stack of these cards ready to personalize and distribute to your family and friends. Tuck them in a lunchbox, mailbox or tote bag as a surprise for your family and special friends. These are great to give to kids and students. Print the message cards on paper and color with your favorite tools.

- Share the love, inspire and touch the world! Print in small sizes, cut and color and leave the happy message cards in public places as surprises to be found by unknowing strangers.

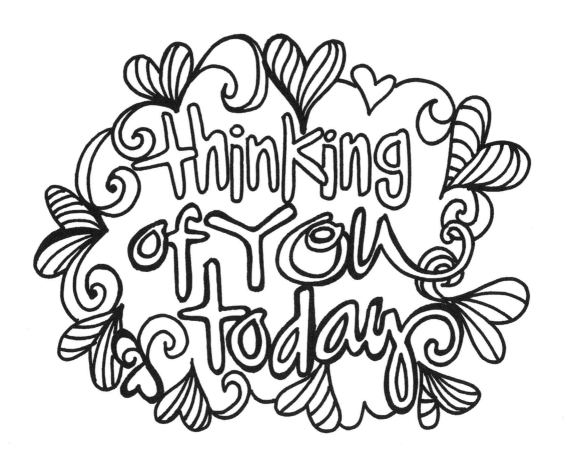

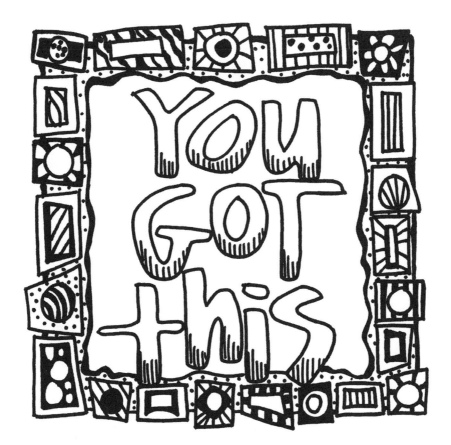

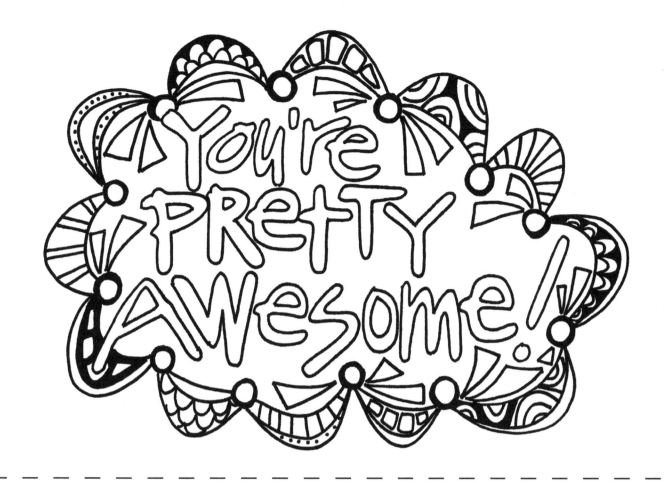

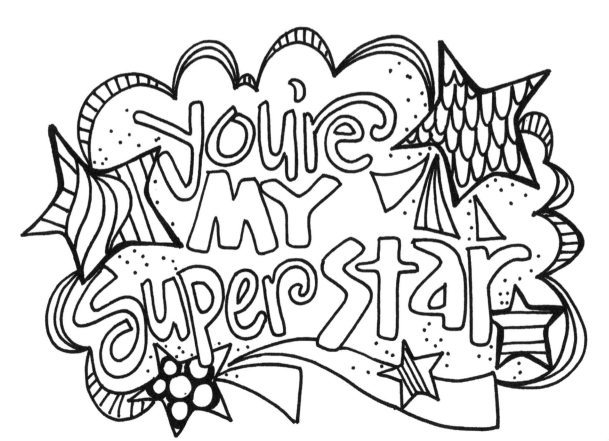

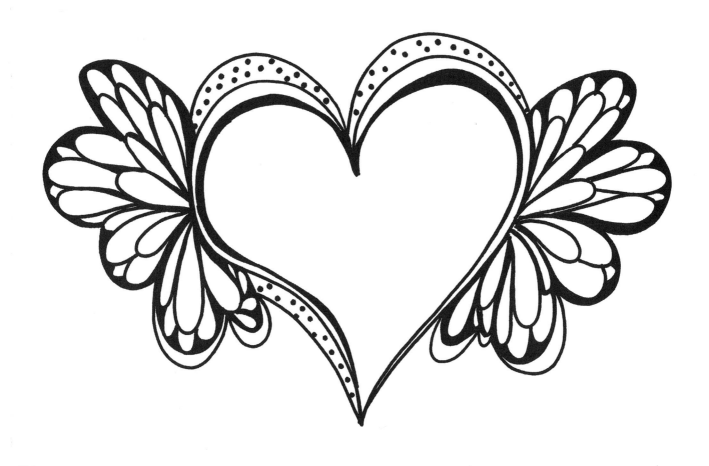

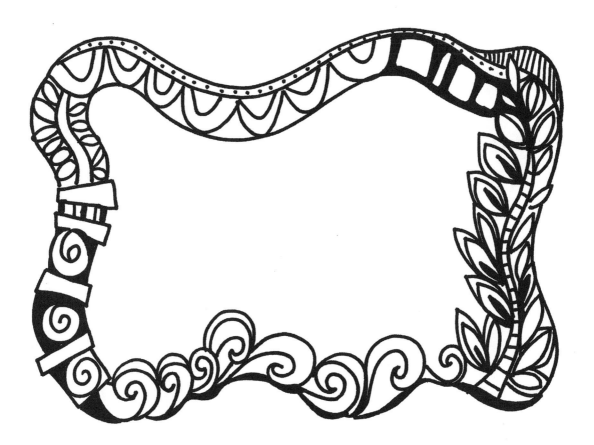

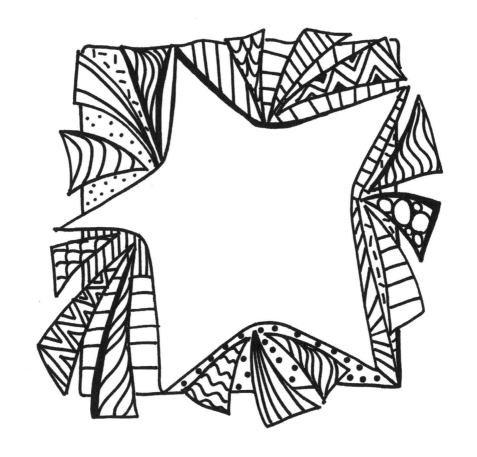

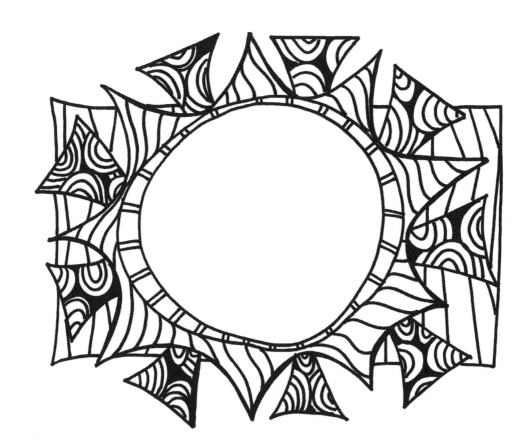

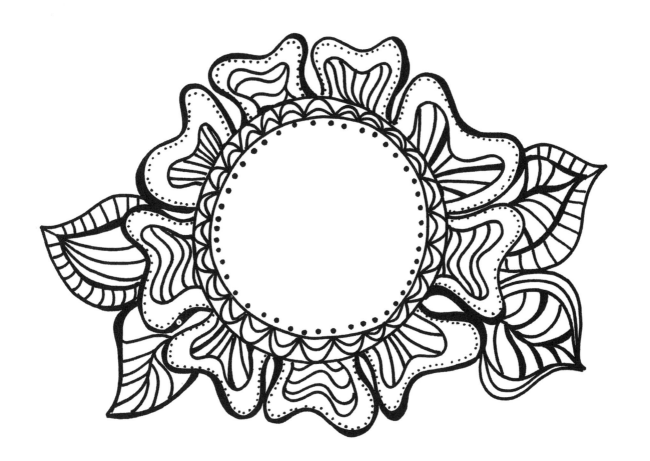

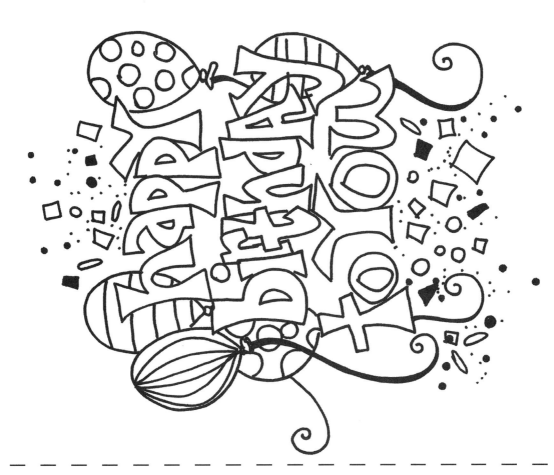

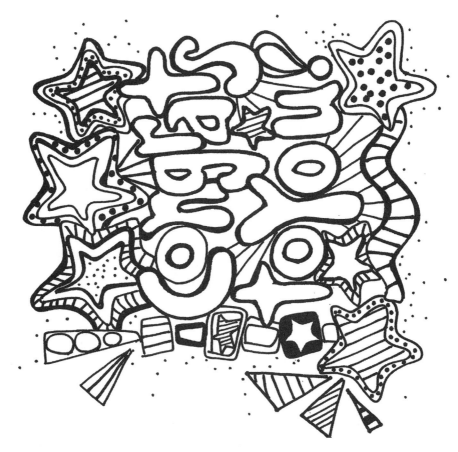

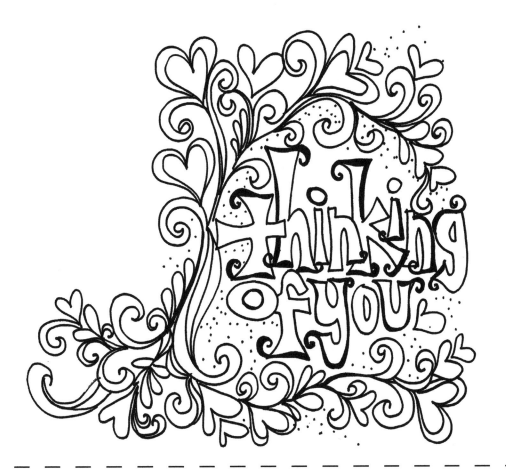

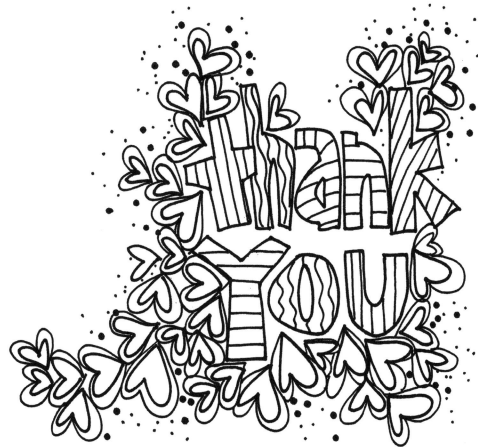

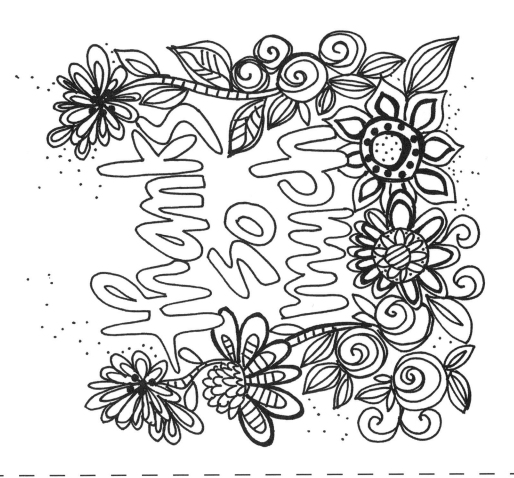

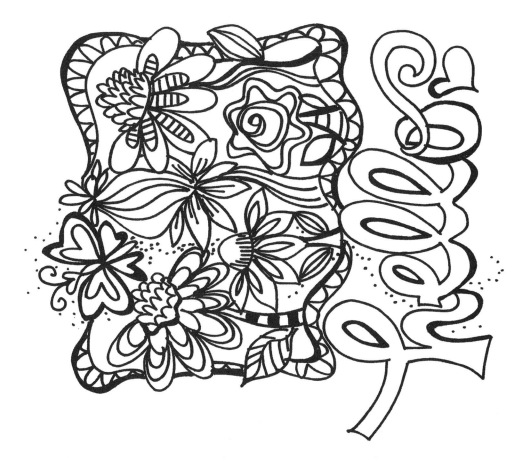

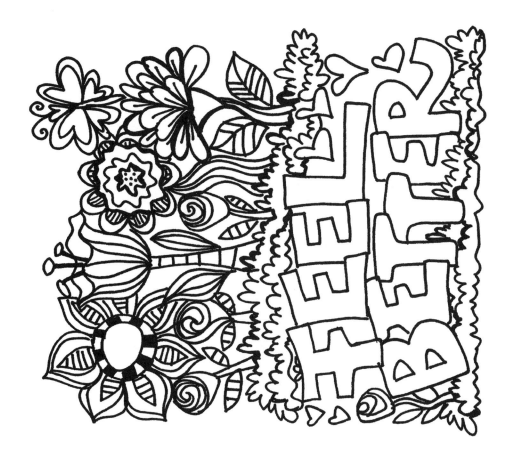

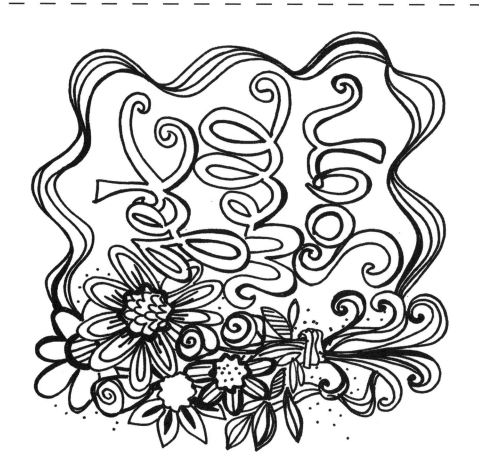

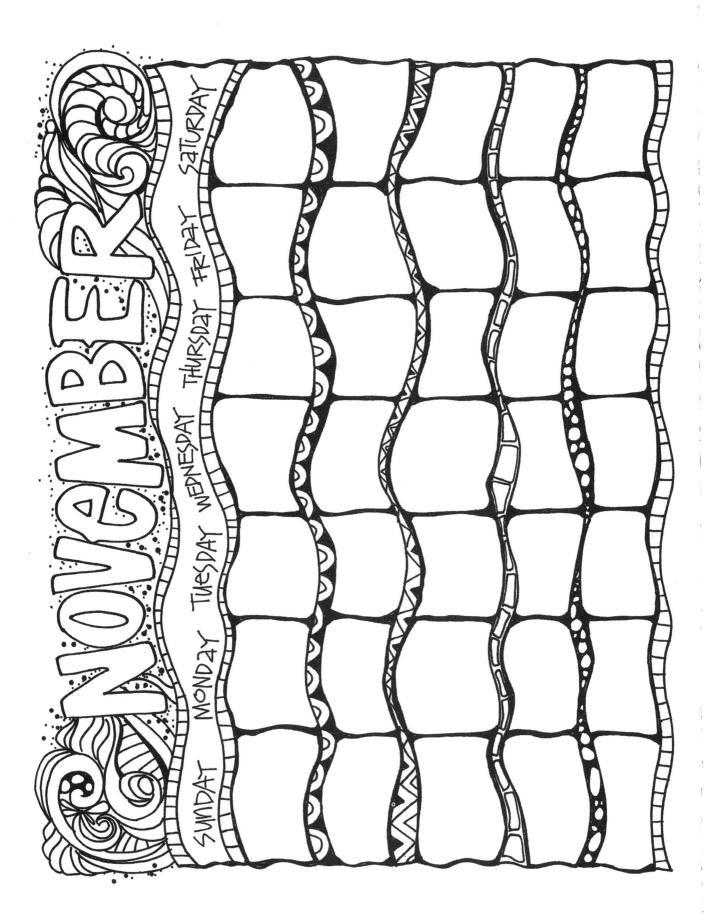

CALENDARS

Do you have a favorite calendar you use every year?
Put your coloring skills in motion to create
your own in your favorite custom colors.

⊚ Take advantage of these monthly pages at full
size. Color with your favorite markers and use
seasonal colors for each month. At home, this is
perfect fridge art, displayed prominently with
magnets for easy access and everyday view.

⊚ Copy, bind and gift large or small versions of the
calendar for a specific audience like grandpar-
ents, college kids, teachers, etc.

⊚ Make your personal or family calendar mini and
portable. Take the master sheets to a copy shop,
reduce the page size and have them printed on
cardstock . Have the sheets assembled with a coil
or plastic binding to flip the pages. These are per-
fect for carrying in a purse or tote bag so you can
color on the go.

⊚ Customize and create a "Birthday Calendar" for
family and friends. Copy and print one master
copy of all twelve months. On the master, hand-
letter the birthday dates of every family member
in each month. Make enough copies, spiral-bound
and uncolored, to distribute to each family mem-
ber. Everyone will enjoy coloring his or her own
calendar to remember special dates.

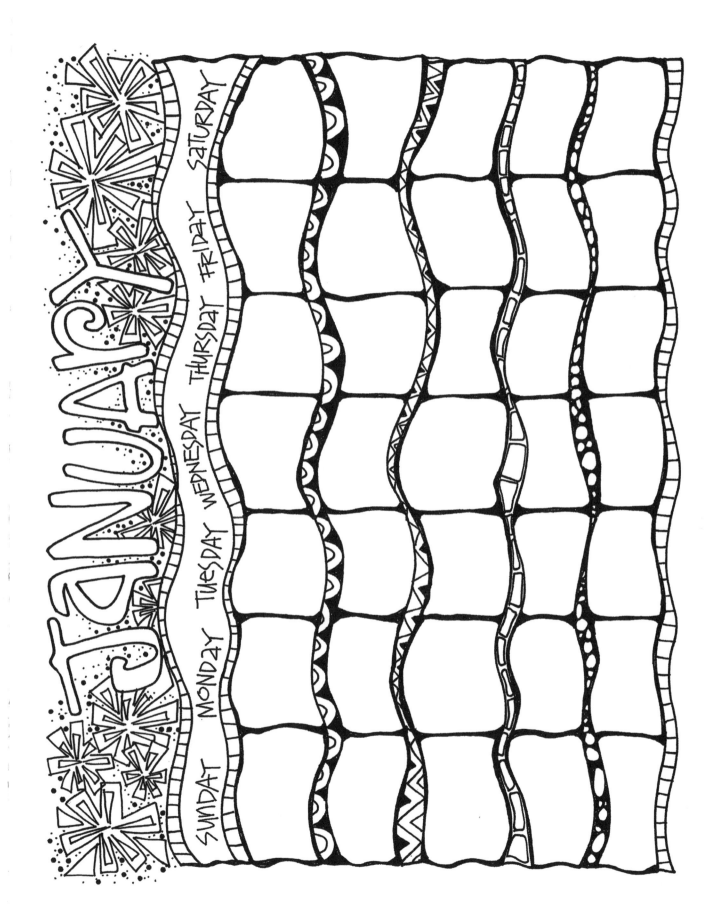

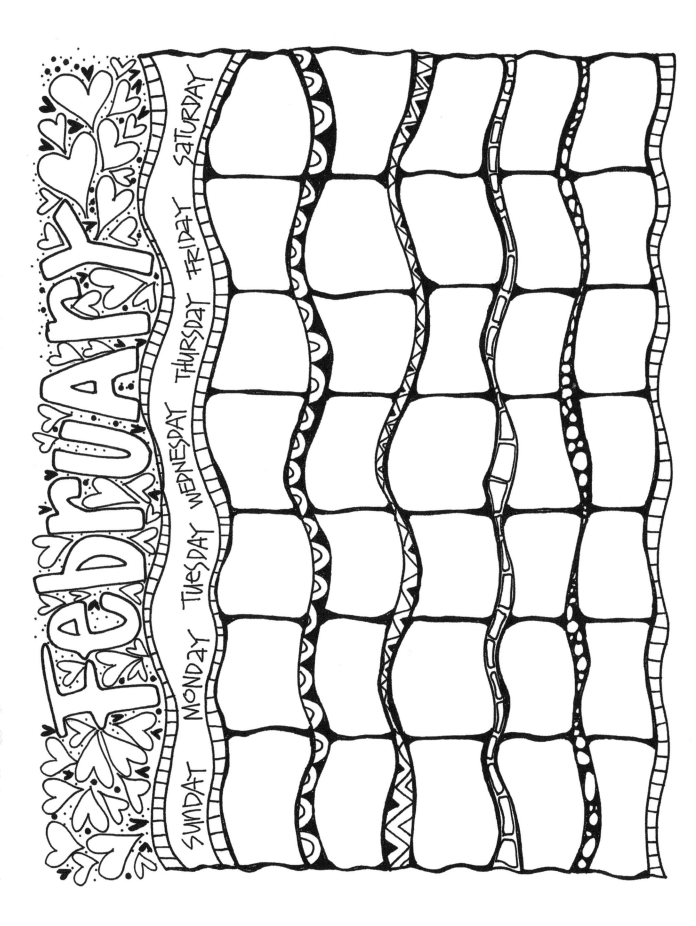

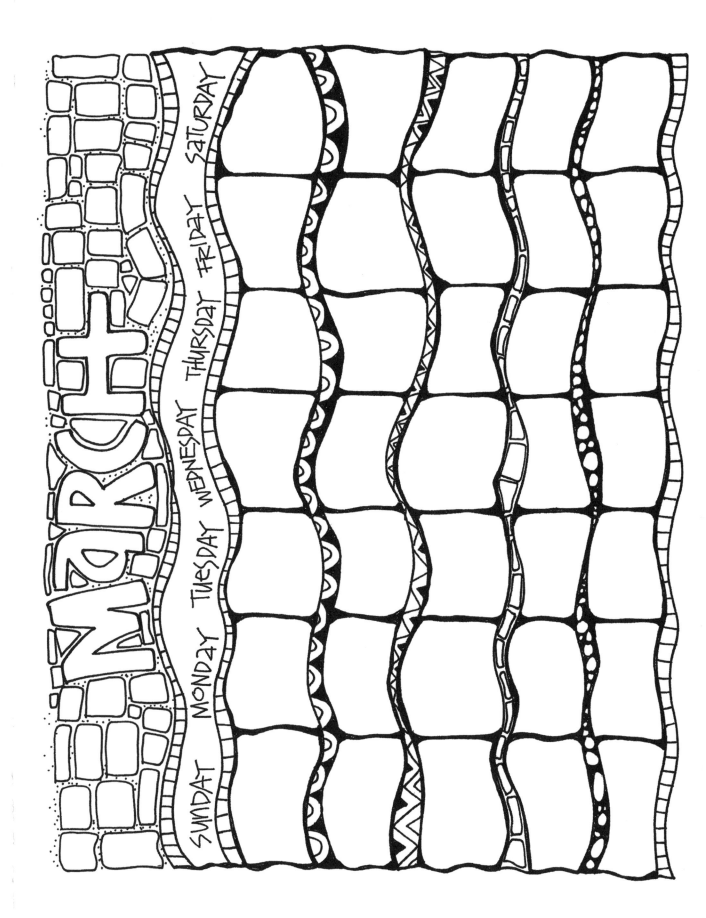

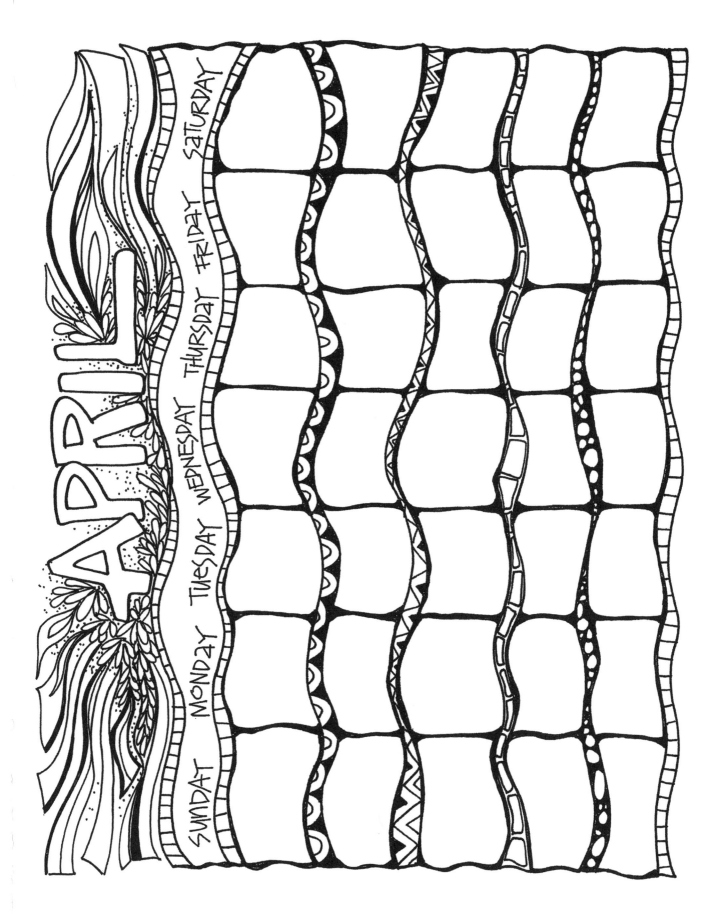

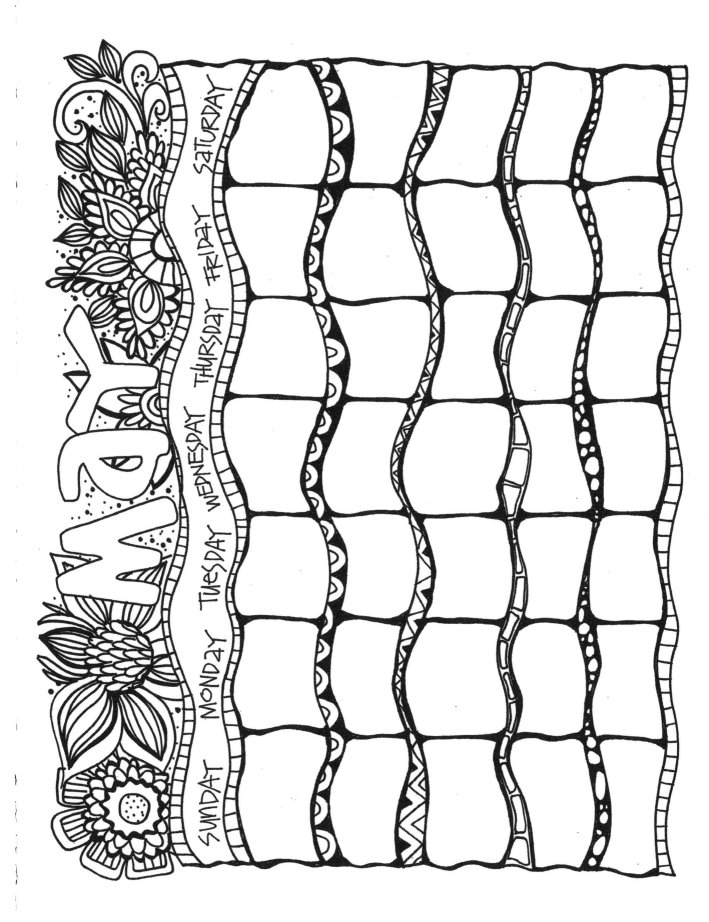

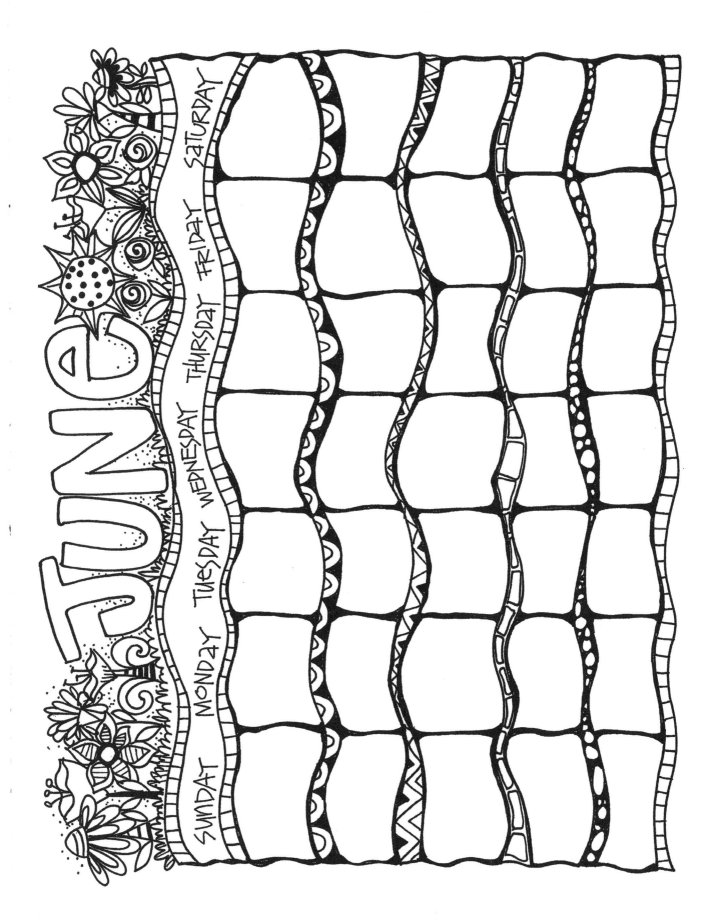

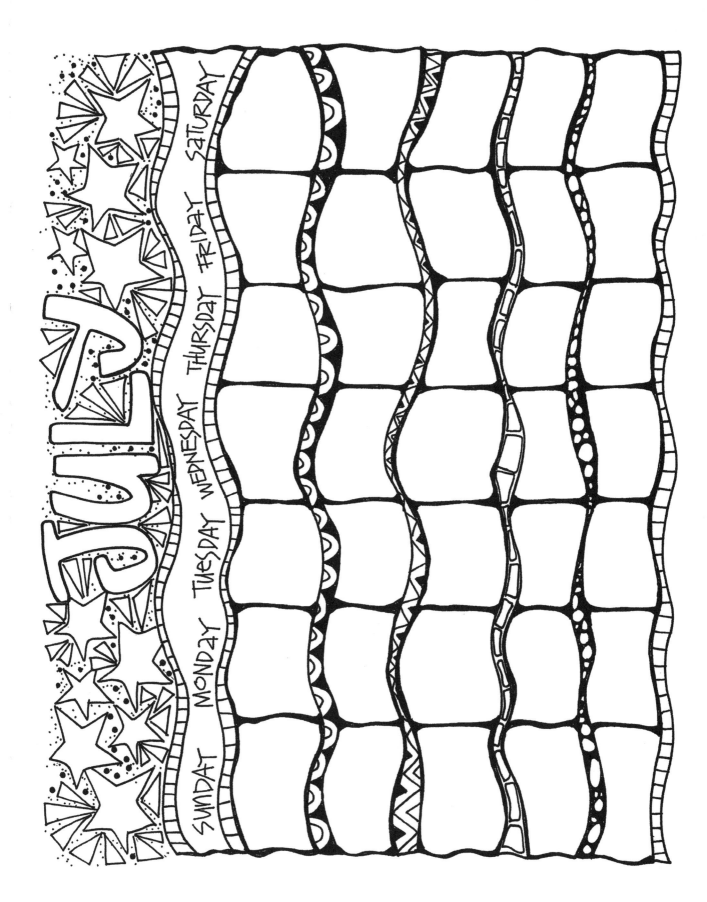

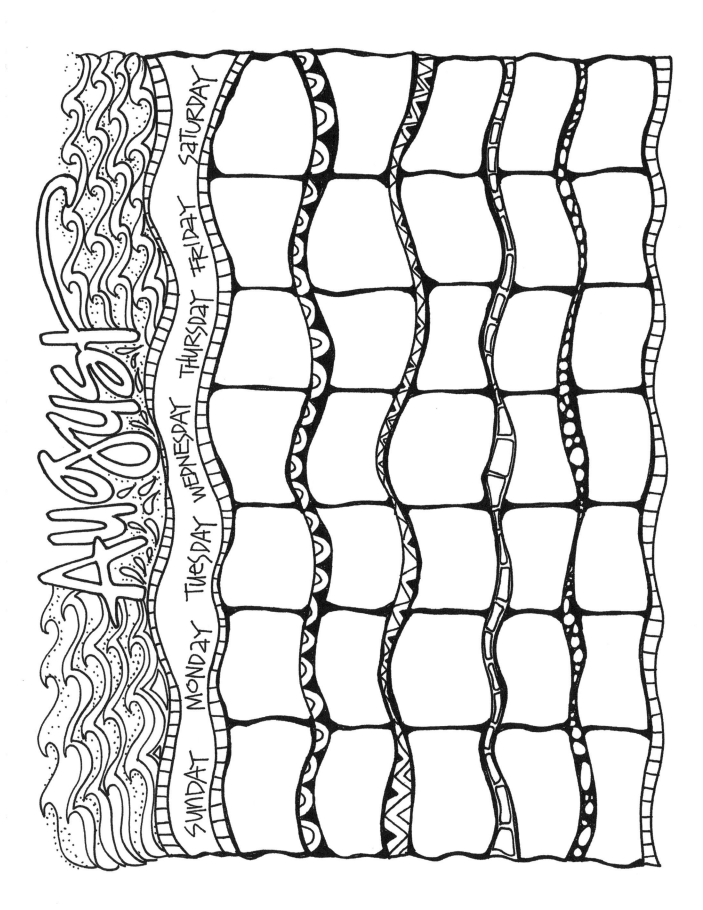

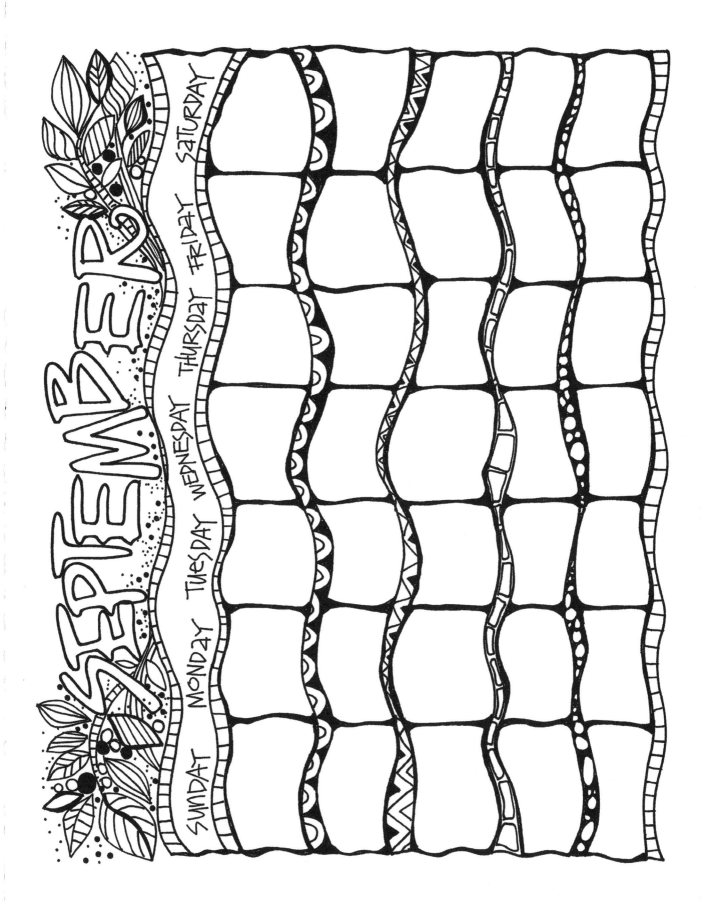

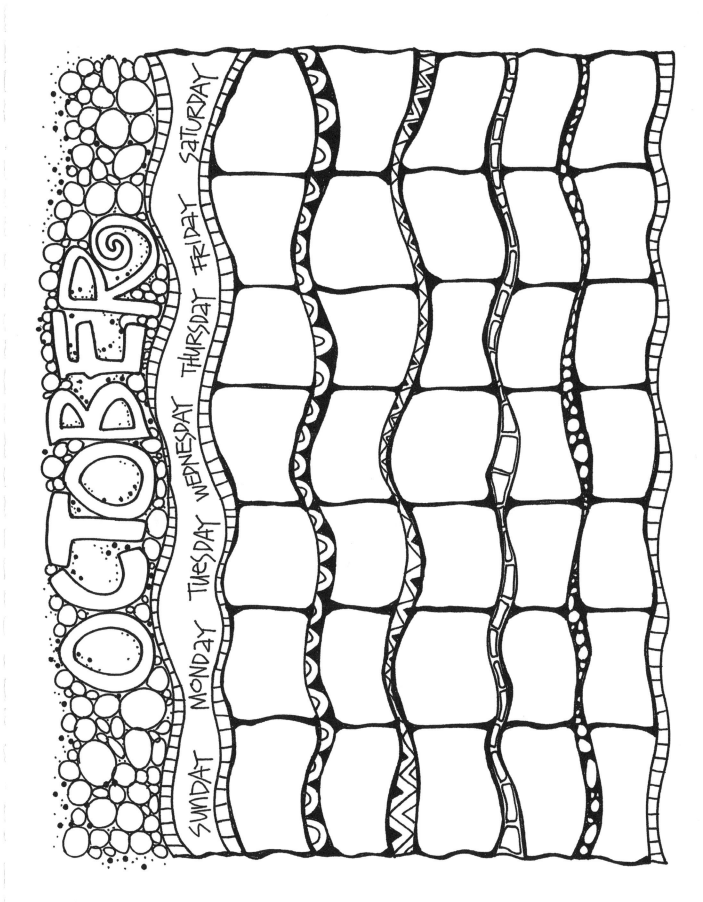

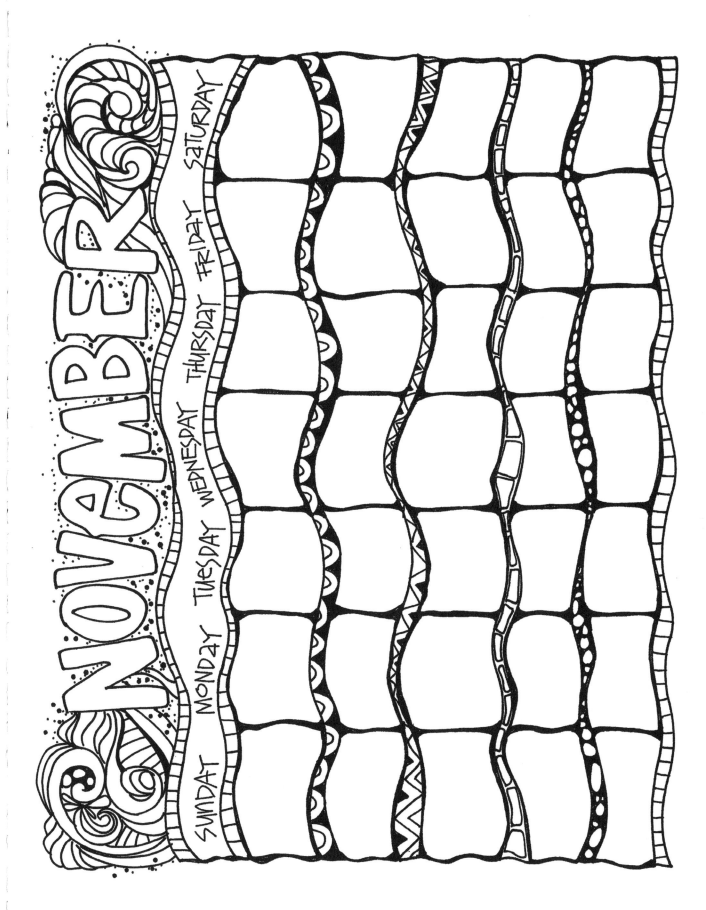

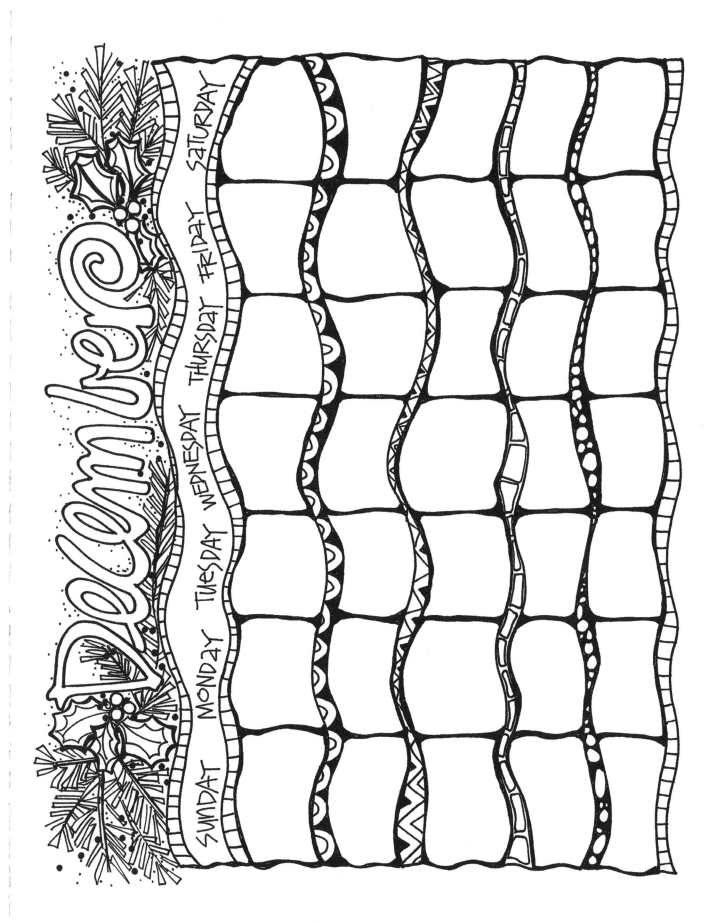

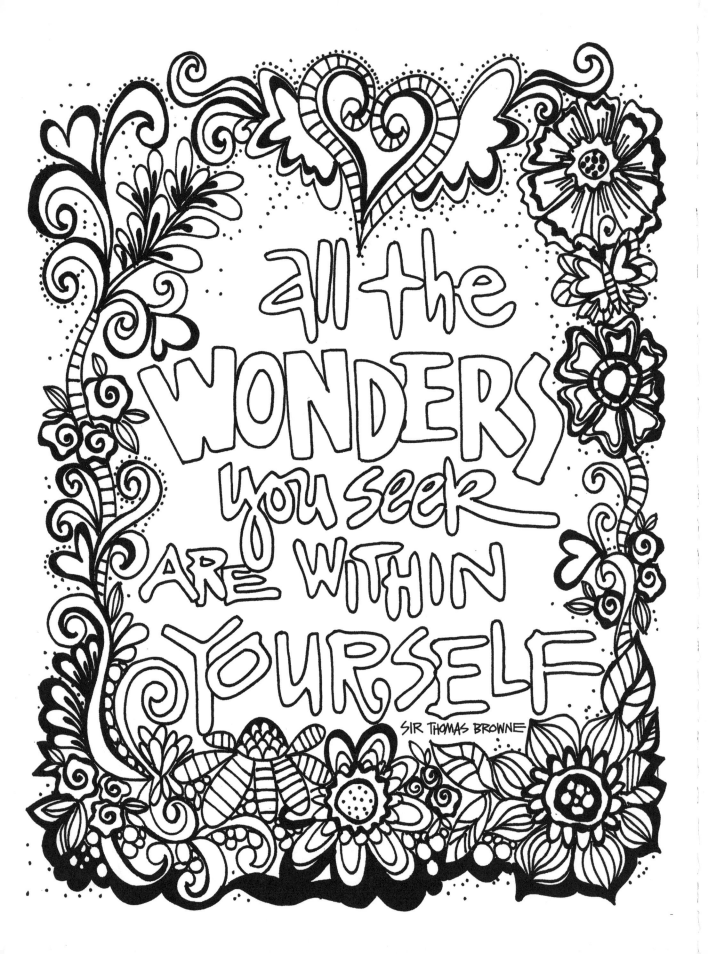

DAILY INSPIRATION

Illustrated words, quotes and poetry can provide visual bliss and insight for a meaningful life. This collection of inspirational designs illustrates a few of my favorite quotes to serve as gentle messages and reminders of life's goodness. These particular coloring pages are practical for making wall art for personal décor or gift giving. The coloring possibilities are endless, so you can make many versions of the art, and none will ever be the same.

- Use an inspirational coloring page to serve as a theme for each month in your home, workplace or classroom. With colored pencils or markers, color a full-sized inspiration page and display it where it is clearly visible such as on a mirror, bulletin board, door, etc.

- Make a mixed-media coloring piece with the inspirational art pages for gifts or encouragement. Mix up your coloring tools to add vibrant variety using colored pencils, markers, sparkly glittering gel pens, watercolors and even acrylic paints. Color the different areas of one page with the various mediums.

- Print multiple sizes of the designs and color the quote pages on heavier paper, like cardstock. Keep colored cards handy for giveaways for family, friends and co-workers.

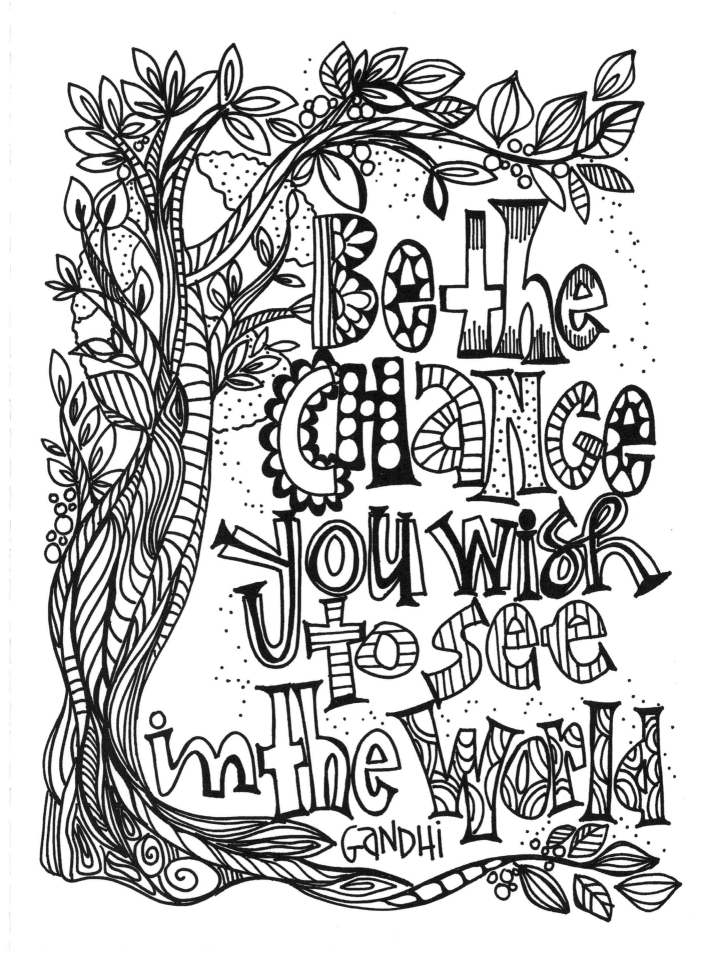

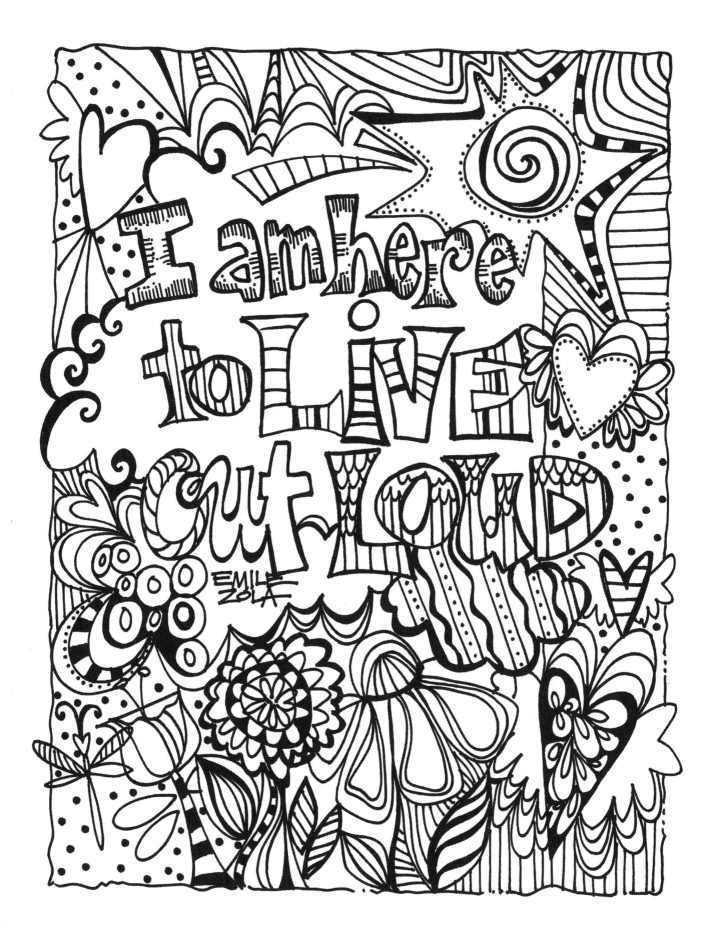

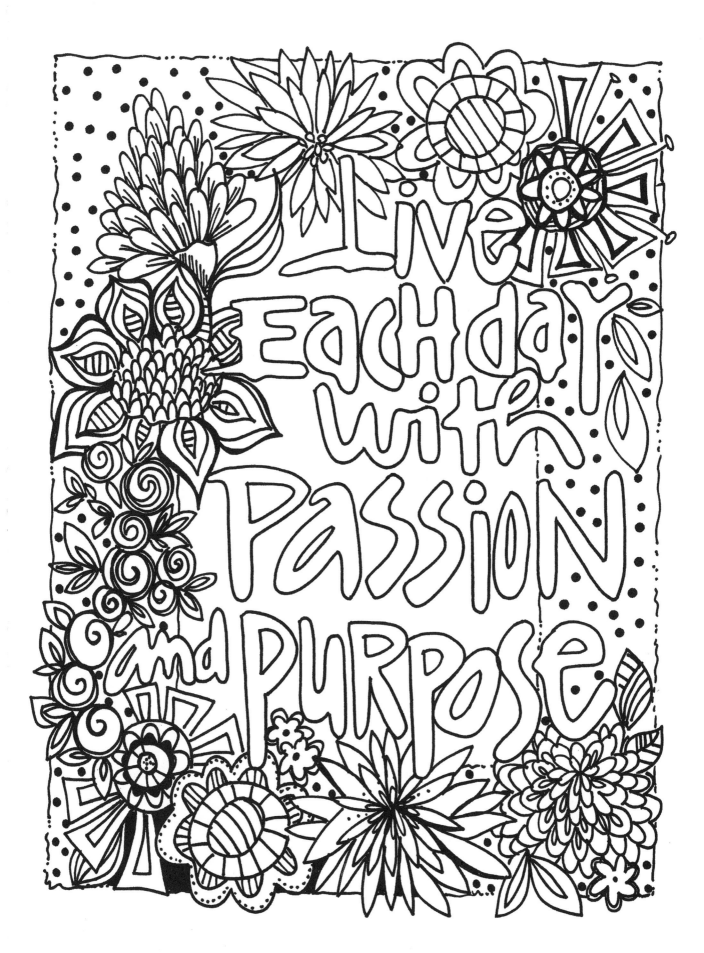

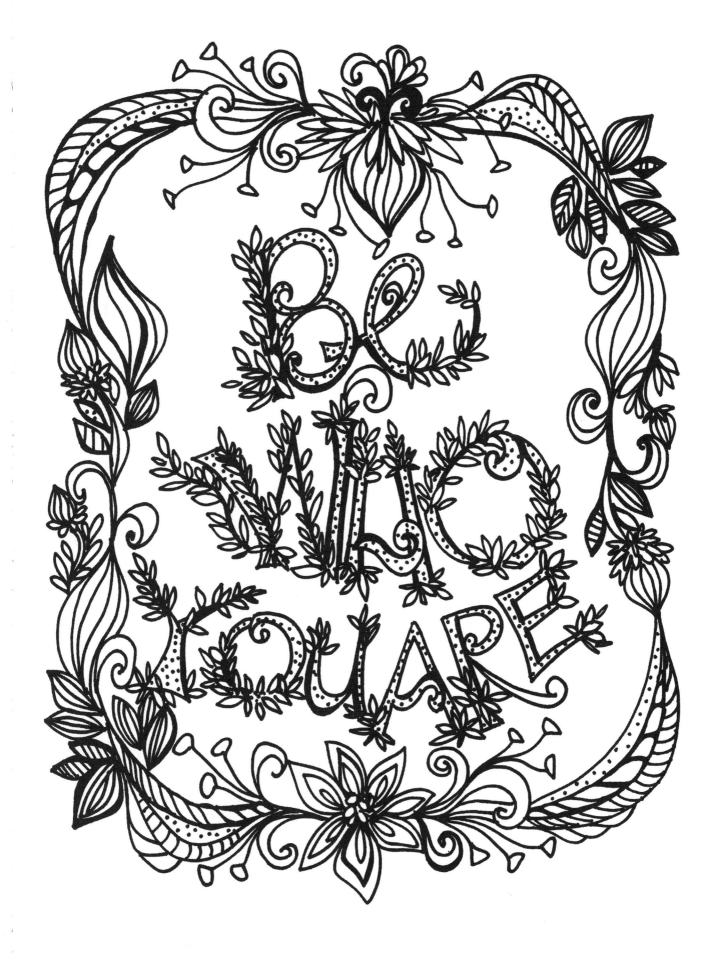

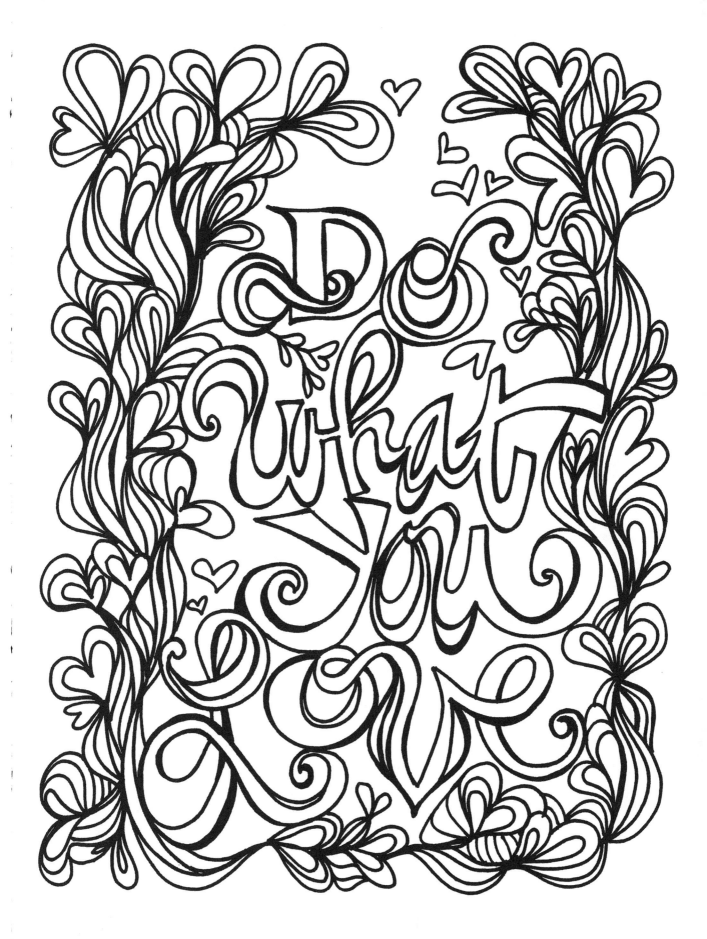

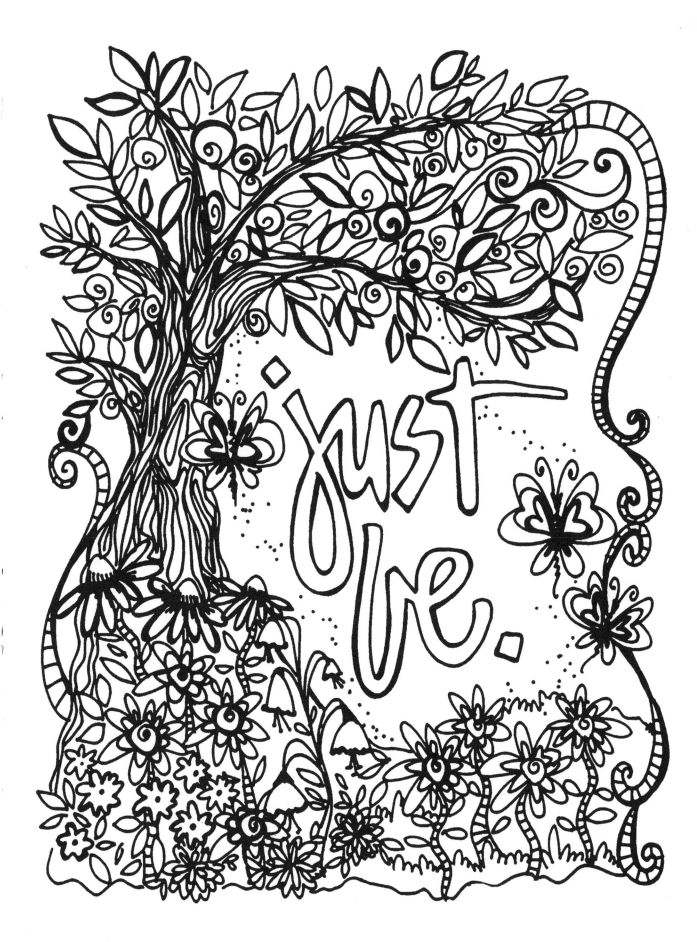

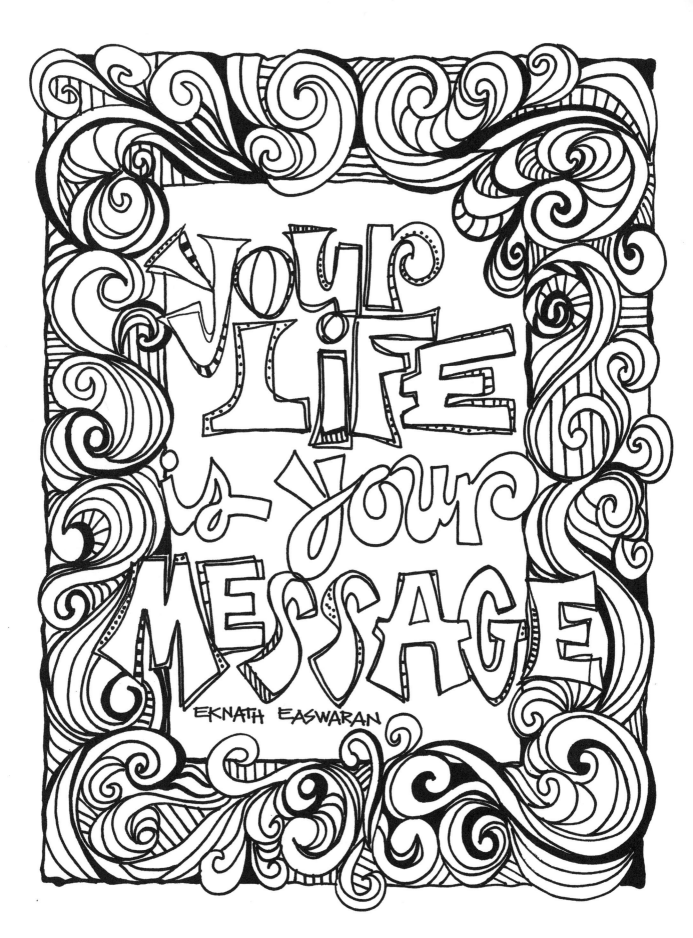

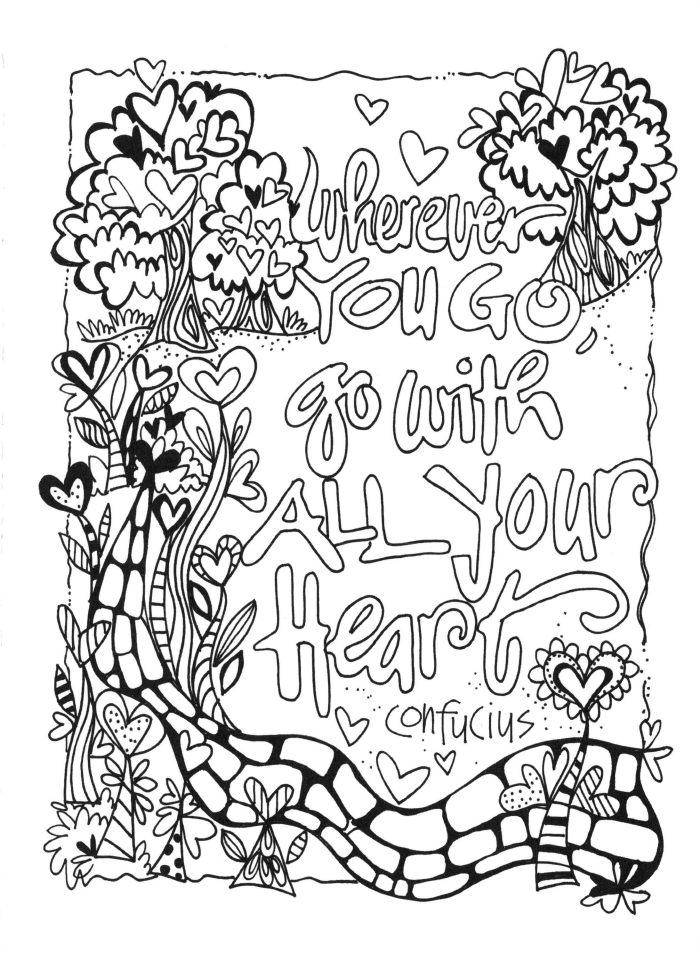

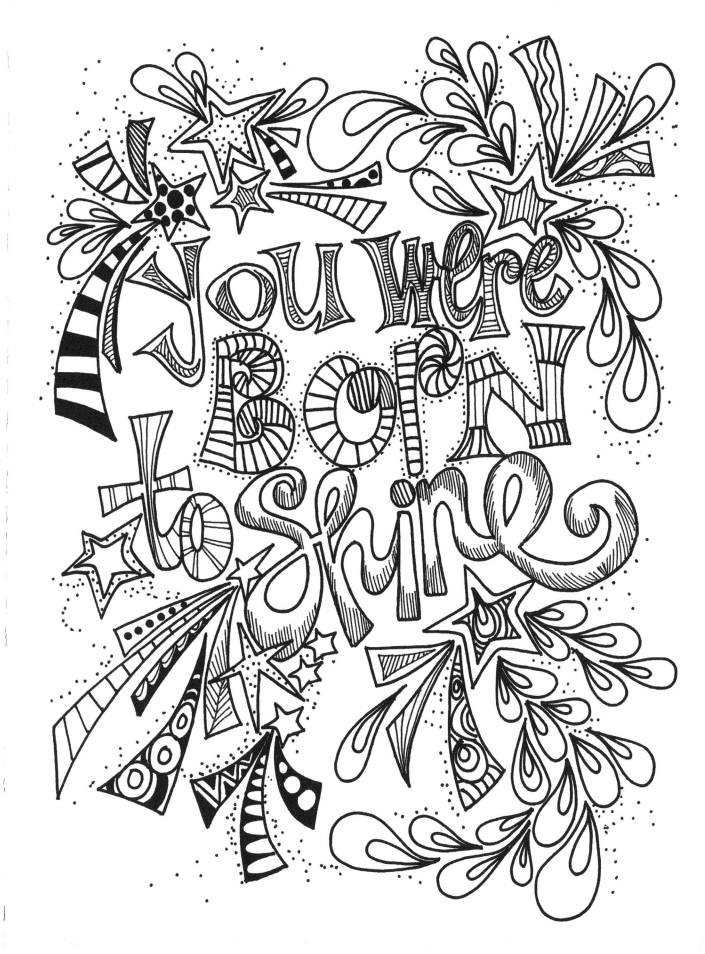

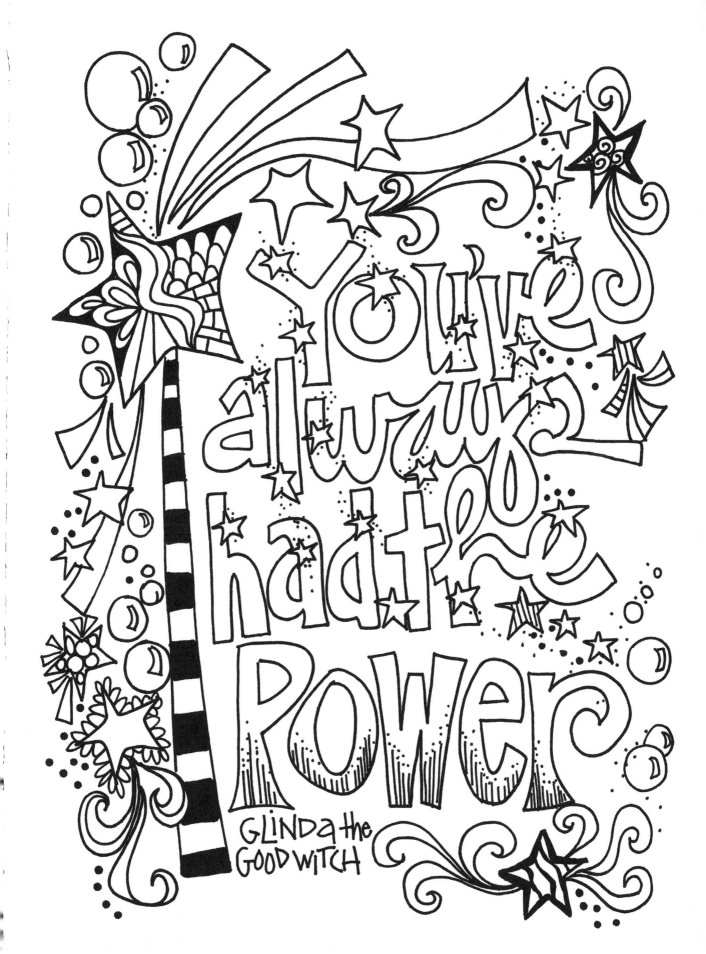

You've always had the Power

GLINDA the GOOD WITCH

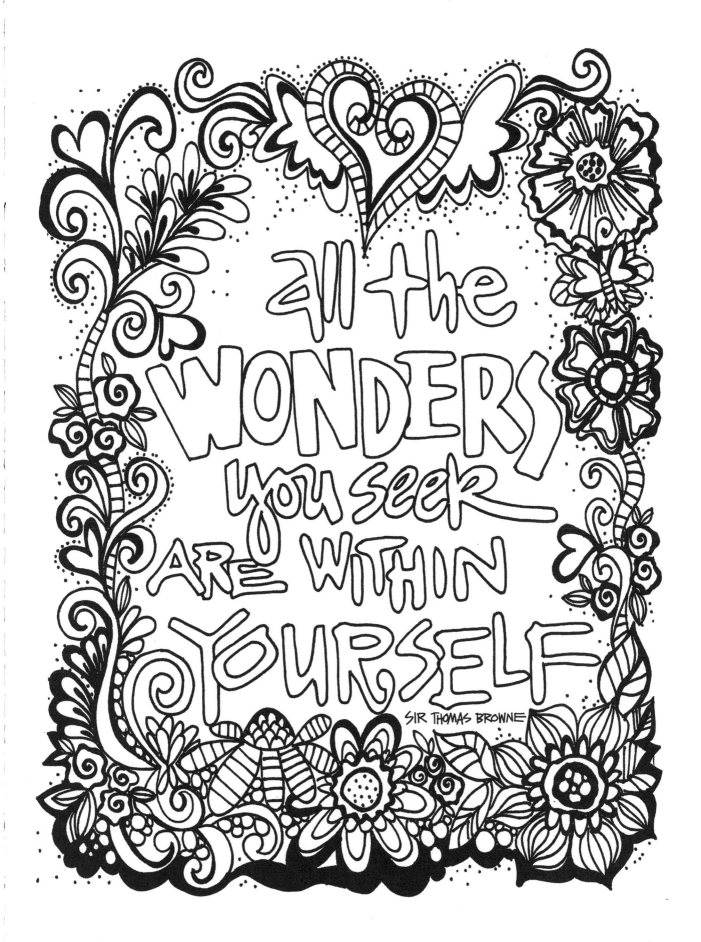

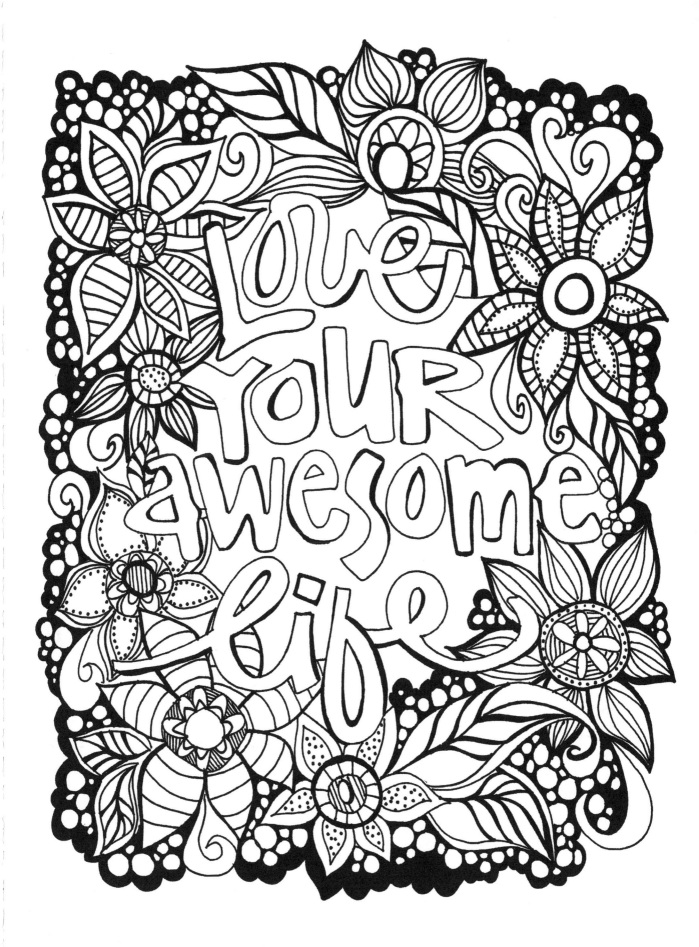

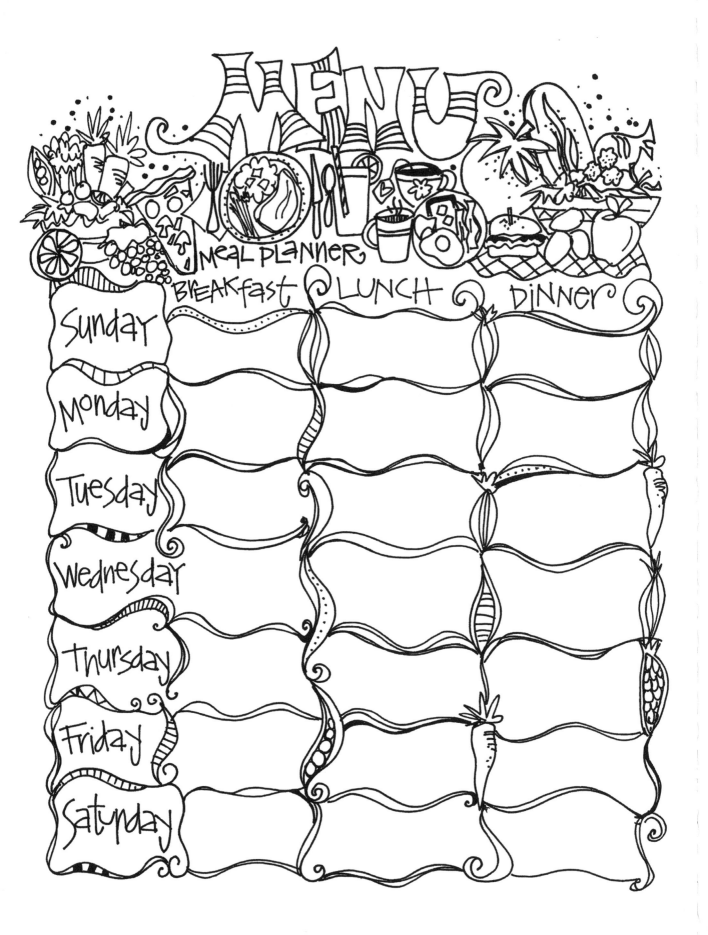

MENU

Meal Planner

	BREAKFAST	LUNCH	DINNER
Sunday			
Monday			
Tuesday			
Wednesday			
Thursday			
Friday			
Saturday			

PLANNING and JOURNALING

Step away from technology and handwrite the details of daily recollections and reflection. Define your life intentions. Plan special menus and celebrations on your own colorful copies of master pages ready to use repeatedly.

- Copy the master pages at full size for journaling, making a menu and listing celebrations. Have them coil-bound into a large flipbook for coloring.

- Print and color a monthly menu using four copies of the master art page. Change the look each time, coloring your planning pages with your pencils and markers using seasonal color stories and palettes.

- Make your own journals using the Sunday through Saturday art pages to document your daily life and reflect on your thoughts. Use the daily writing spaces to make volumes of gratitude journals that you can print and color over and over again.

- Have your custom journals printed and cut to any size on any type of cardstock. Have the books coil-bound and give them uncolored as gifts to teens, friends, teachers, family, etc.

- With large spaces for writing, use the weekly pages to create a daily prayer or meditation journal. Color the pages using your favorite color schemes, and use different pens for writing to add interest to the pages.

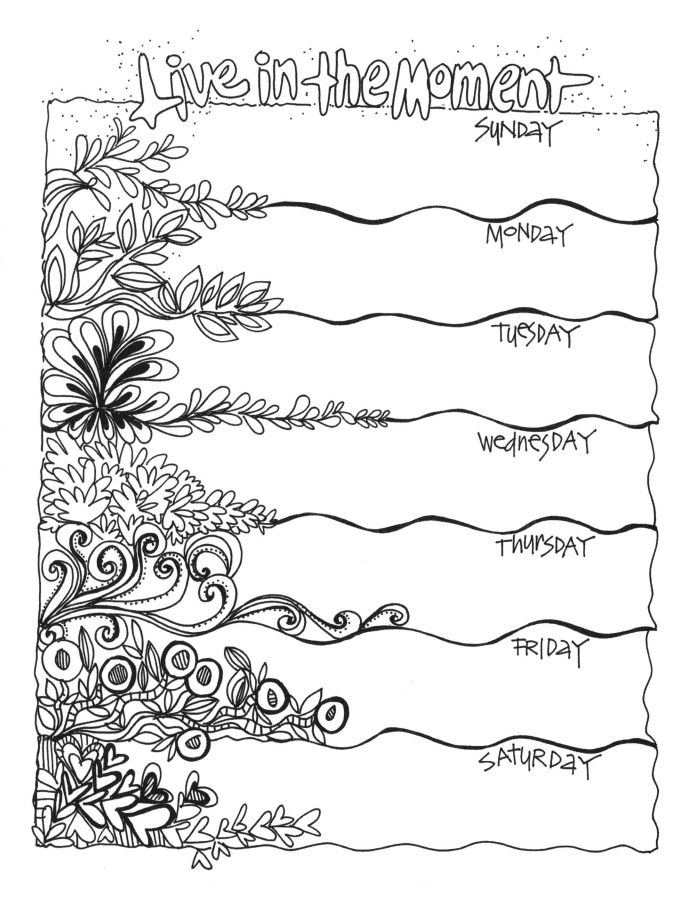

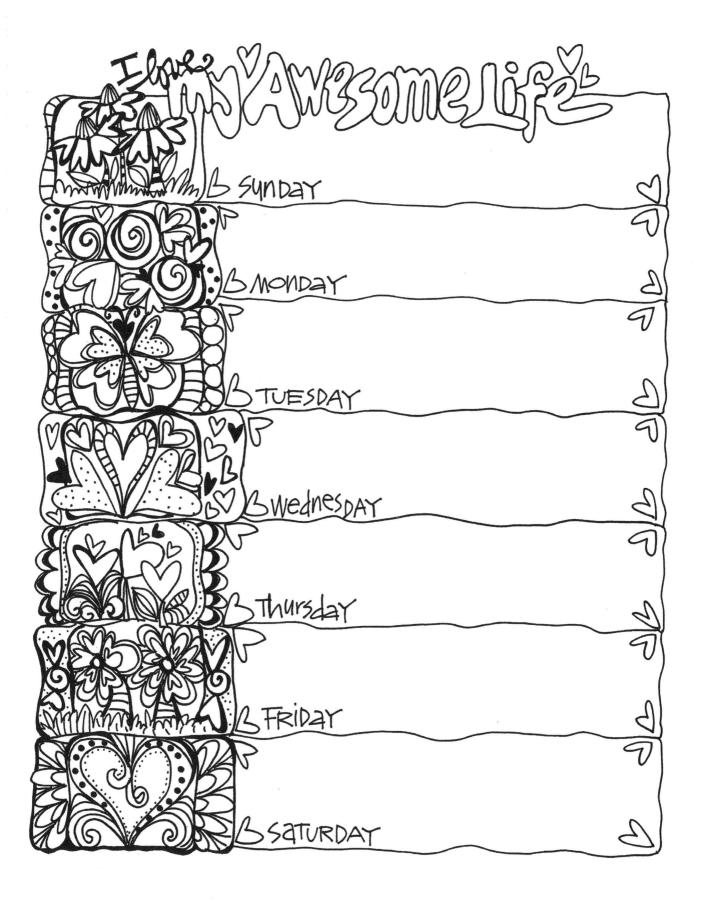

I love my Awesome Life

Sunday

Monday

Tuesday

Wednesday

Thursday

Friday

Saturday

TODAY'S THE DAY...

SUNDAY

MONDAY

TUESDAY

WEDNESDAY

THURSDAY

FRIDAY

SATURDAY

Daily Intentions

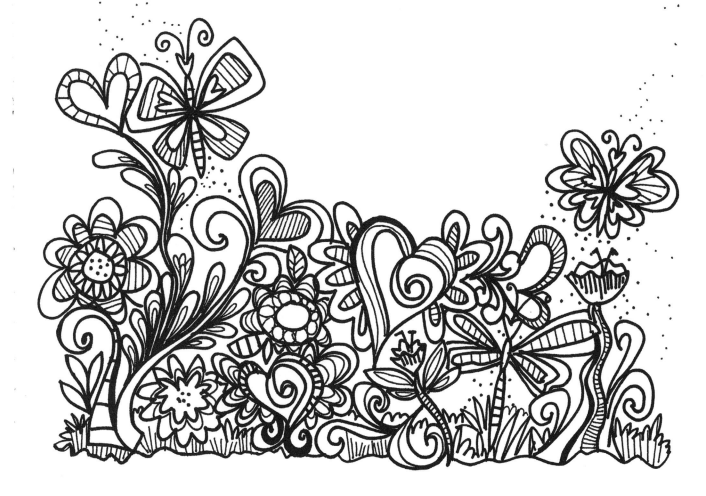

gathering quiet thoughts...

in my heart... my soul... my spirit...

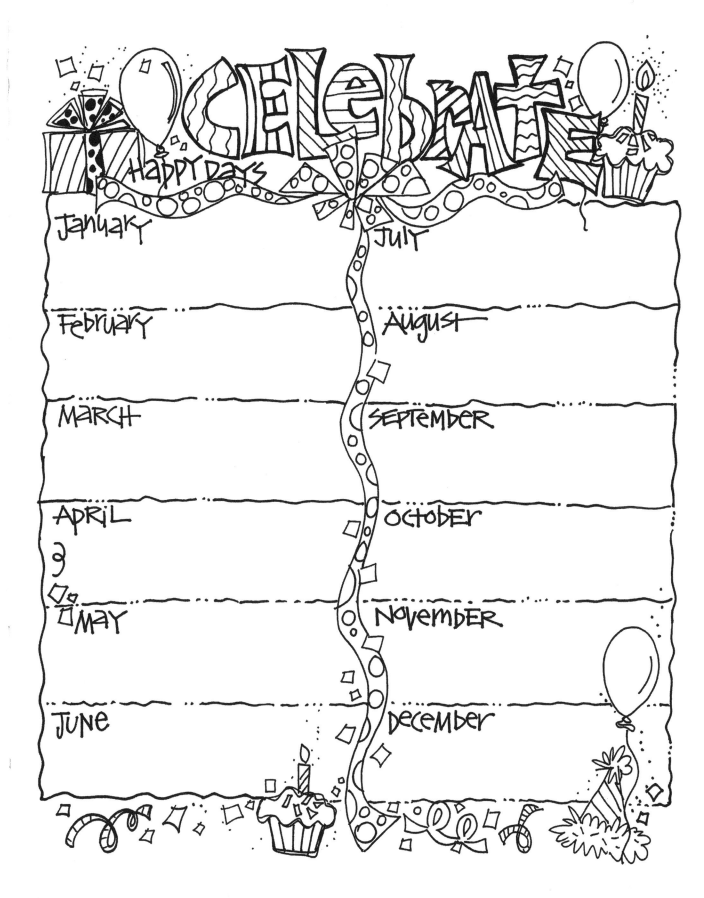

Celebrate!
Happy Days

January

February

March

April

May

June

July

August

September

October

November

December

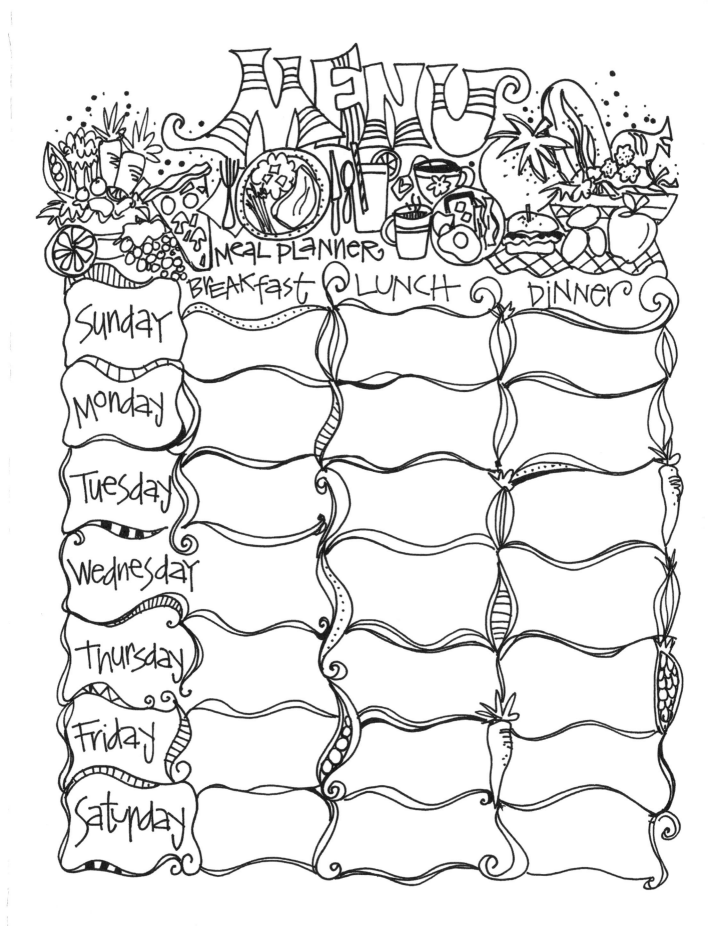

MENU

MEAL PLANNER

	BREAKFAST	LUNCH	DINNER
Sunday			
Monday			
Tuesday			
Wednesday			
Thursday			
Friday			
Saturday			

DEDICATION

This book is for my colorful parents, Ronnie and Stan Zawacki. For Mom who always provided the crayons, taught me to color in the lines beautifully and aspire to perfection with pride in everything we do. For Dad, who encouraged me take those skills and live an authentic, artful life coloring outside the lines. They knew my heart, and had the perfect recipe for this daughter to live her dream as an artist.

Other fine North Light Books are available from your favorite
bookstore, art supply store or online supplier. Visit our
website at fwmedia.com.

a content + ecommerce company

20 19 18 17 16 5 4 3 2 1

Distributed in Canada by Fraser Direct
100 Armstrong Avenue
Georgetown, ON, Canada L7G 5S4
Tel: (905) 877-4411

Distributed in the U.K. and Europe
by F&W Media International LTD
Brunel House, Forde Close, Newton Abbot, TQ12 4PU, UK
Tel: (+44) 1626 323200, Fax: (+44) 1626 323319
Email: enquiries@fwmedia.com

ISBN 13: 978-1-4403-4911-9

Edited by Tonia Jenny
Interior designed by Jared Fetters
Production coordinated by Jennifer Bass
Photography by Zenna James

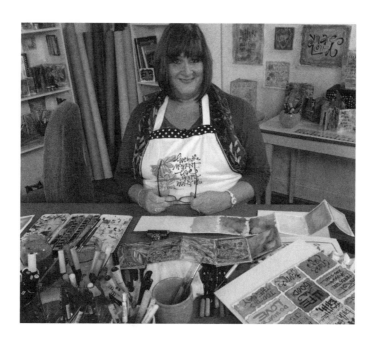

JOANNE SHARPE

Joanne Sharpe is an energetic, whimsical artist dedicated to empowering women to embrace their creativity through online classes and traveling workshops that explore artful sewing, journaling, hand-lettering, and a variety of mixed-media and textile art forms. She is the author of the best-selling title *The Art of Whimsical Lettering* (Interweave 2014), named an Amazon's Editor's Pick for a Best Craft Book of 2014. Joanne is proud to be a BERNINA Artisan Ambassador, sharing her love of threads and fabric with an audience eager to learn how to bring these expressive media into their own artwork. Look for her second book, *The Art of Whimsical Stitching*, a colorful handbook of ideas and techniques for playful art sewing. Joanne resides in Rochester, New York, with her very supportive husband, is the mom to a daughter, three sons and a first time grandma to a precious baby girl. Follow all Joanne's artful adventures at: joannesharpe.com

Ideas. Instruction. Inspiration.

Receive FREE downloadable bonus materials when you sign up
for our free newsletter at ClothPaperScissors.com.

Find the latest issues of *Cloth
Paper Scissors* on newsstands, or
visit shop.clothpaperscissors.com.

These and other fine North
Light products are available at
your favorite art & craft retailer,
bookstore or online supplier.
Visit our websites at artistsnetwork.com, interweavestore.com
and artistsnetwork.tv.

 Follow ClothPaperScissors for
the latest news, free wallpapers,
free demos and chances to win
FREE BOOKS!

Get your art in print!

Visit artistsnetwork.com/category/competitions
for up-to-date information on *Incite* and other
North Light competitions.